IMAGES
of America

CARMEL

IMAGES
of America

CARMEL

Terri Horvath

ARCADIA
PUBLISHING

Published by Arcadia Publishing
Charleston SC, Chicago IL, Portsmouth NH, San Francisco CA

Printed in the United States of America

Library of Congress Catalog Card Number: 2006939089

For all general information contact Arcadia Publishing at:
Telephone 843-853-2070
Fax 843-853-0044
E-mail sales@arcadiapublishing.com
For customer service and orders:
Toll-Free 1-888-313-2665

Visit us on the Internet at www.arcadiapublishing.com

*Dedicated to the explorers and pioneers who built
Carmel, Indiana, and to my husband and family,
who have encouraged my own small explorations.*

CONTENTS

ACKNOWLEDGMENTS

Many people contributed to the making of this book. Some searched extensively through their own family archives for photographs, while others provided valuable clues in locating missing information. Special thanks goes to Tom Rumer, whose knowledge of Carmel history and lore was invaluable, and to the Carmel Clay Historical Society, a group in a headquarters small in space but rich with materials that preserve the city's past. Other individuals and organizations that deserve recognition are Laura Rippe, Scott Hughey, Harold Kaiser, Tom Kirk, Phyllis Morrow, Danny O'Malia, Marvin Pike, Mike Wannemacher, the office of the mayor of Carmel, the office of the clerk-treasurer, the Hamilton County surveyor's office, Carmel High School, the Carmel Symphony Orchestra, the Museum of Miniature Houses and Other Collections, the Indiana Historical Society, the United States Senate Historical Office, and the agriculture communications department at Purdue University. Thanks are also due the following authors for their research: Phil Hinshaw, Jerry Marlette, Isabelle C. Fearheiley, Frank S. Campbell, Dorothy Smith, and John G. Foland.

INTRODUCTION

Swampy, heavily wooded land greeted the first white settlers who came to the area eventually known as Carmel. Populated by hundreds of frogs, Tadpoles' Glory was the nickname that traders and American Indian tribes once used for the area. By 1837, a town named Bethlehem was established. Carmel did not receive its current name until town residents decided they needed a post office in 1846. Since a southern Indiana town used the name of Bethlehem first, another Biblical name was chosen—Carmel, meaning "beautiful gardens."

For more than a century, Carmel maintained its small-town allure. One local historian noted for Carmel's centennial celebration that the town was "a modern little city with comfortable and beautiful homes, well kept lawns. There are no rich aristocrats in Carmel and no dire poverty."

It remained little changed until the 1950s. With the rise of the automobile's popularity came a massive shift in demographics. The allure of small-town life within easy access of the big city of Indianapolis brought hundreds of new residents to Carmel and the surrounding area. The extension of Keystone Avenue through Carmel in 1965 made travel even easier and speedier. Plus during the same year, the areas of Woodland Springs, Cool Creek, and Keystone Square were annexed to Carmel, doubling the population.

Another of Carmel's attractions for prospective residents was its emphasis on high quality education, a tradition started by Quakers who first settled here around 1833. By 2003, Carmel had the largest high school in Indiana with about 3,500 students. The school administration has continuously improved the educational standards, reflected by the recent honor as one of Indiana's "outperforming" school districts by Standard and Poor's School Evaluation Services. It was one among only 16 of Indiana's 294 districts selected. Carmel High School was also recognized by the Indiana Chamber of Commerce as one of the six "Head of Class" high schools in Indiana. In 2006, the school also counted 25 National Merit Semifinalists among its students.

The town itself had grown, mostly with the addition of subdivisions. The first census in 1925 shows a population of 385. By 1950, the town held 1,009 people, and in 1970, 6,580. Today about 66,000 people reside here. In fact, many of the central Indiana current business leaders live in Carmel and Clay Township, including Jim Irsay, the owner of the Indianapolis Colts.

Along with the population growth came business and industry. Carmel government officials have determined that the town's Meridian Corridor has the second largest concentration of office workers in Indiana. Two major companies along this corridor are Delta Faucet and Thomson Consumer Electronics. The corridor is also home to several health care facilities, including St. Vincent Carmel Hospital, which opened in 1985.

Today under the leadership of Mayor James Brainard, Carmel is undergoing even greater changes. In 2003, the city completed the largest annexation in its history, extending its borders even further. A revitalization of the downtown was also underway, showcasing an arts and design district. Nearby is the Performing Arts Center under construction. These are some of the features that helped the city become recognized in 2004 by the *American City Business Journal* as one of the best places to live.

From a swampy, pioneer settlement to rural hamlet and on to city prominence, Carmel has seen a lifetime of major transitions. This book explores some of those transitions within the city and Clay Township.

One

RURAL ROOTS

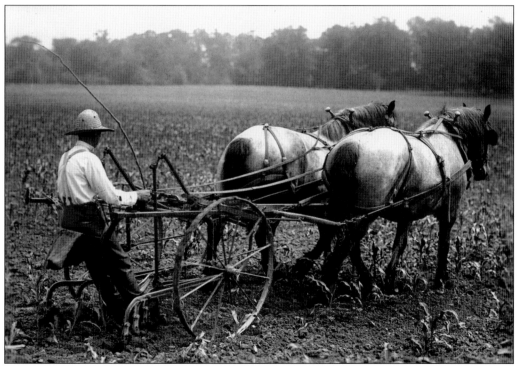

Farms were the lifeblood of the business trade in Carmel for decades. Many families came to the area specifically for the opportunity to farm the rich soil here. The trend continued through the mid-20th century. Some of the showcase farms in Carmel's history were Cricklewood Farm, Happy T. Farm, Gregg Farm, and White Haven. (Courtesy of agriculture communications at Purdue University.)

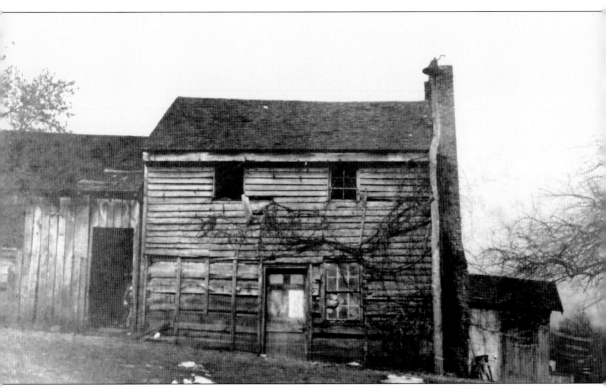

Among the earliest settlers were John and Ruth Kinzer, who built the cabin pictured above in 1828. They started a family in 1832 when their oldest son, William, was born. Eventually the Kinzer cabin was renovated and placed on the National Register of Historical Places. It now sits on private property along Main Street, east of Keystone Avenue. (Courtesy of the Carmel Clay Historical Society.)

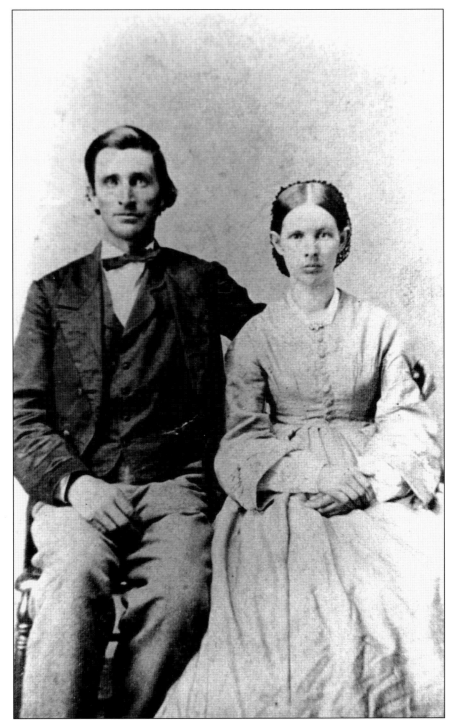

William Kinzer was a successful farmer, living all his life on the home claim of his parents and marrying Maria Mendenhall, who died at the age of 27. He attended the local Quaker meetinghouse, wrote articles for the local weekly newspaper, and held one or more public offices in the township. (Courtesy of the Carmel Clay Historical Society.)

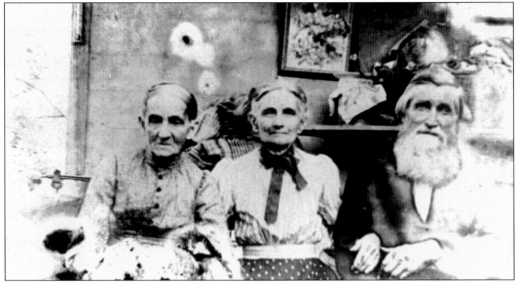

William Kinzer is pictured here, with his second wife, Nancy Moon, and her mother, Rachel Moon (on the left), late in his life. William kept a series of journals beginning in 1857 and continued to about the time of his death in 1914. Copies of these journals, with the exception of two or three years, are stored at the Carmel Clay Historical Society. (Courtesy of the Carmel Clay Historical Society.)

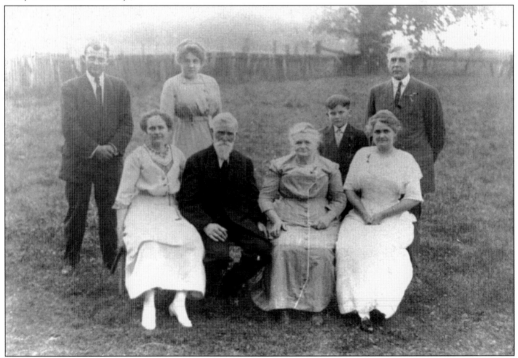

Living alongside William Kinzer was one of his siblings Jacob, who was born in 1837. Jacob (seated) is pictured here with his wife, Louisa Ballard Kinzer (right of Jacob), along with other members of the Kinzer family and their spouses. Jacob died in 1916. (Courtesy of the Carmel Clay Historical Society.)

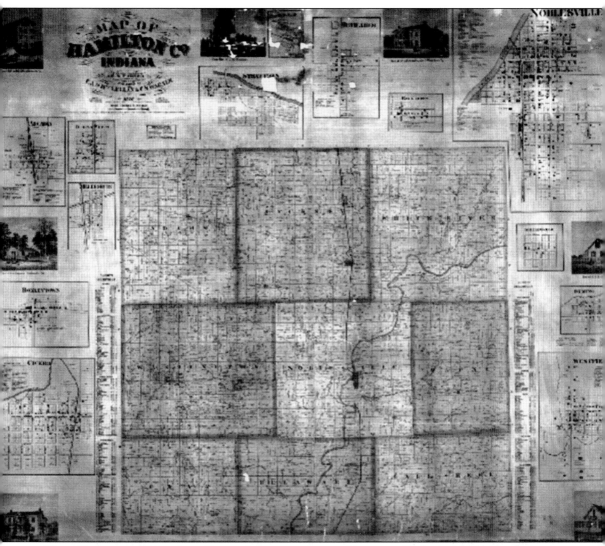

The oldest map of Hamilton County known to exist today was published in 1866. At the time of the map's publication, the borders of Hamilton County—named after the country's first secretary of the Treasury, Alexander Hamilton—had been delineated for about 43 years. These county lines remained unchanged. (Courtesy of the Hamilton County surveyor's office.)

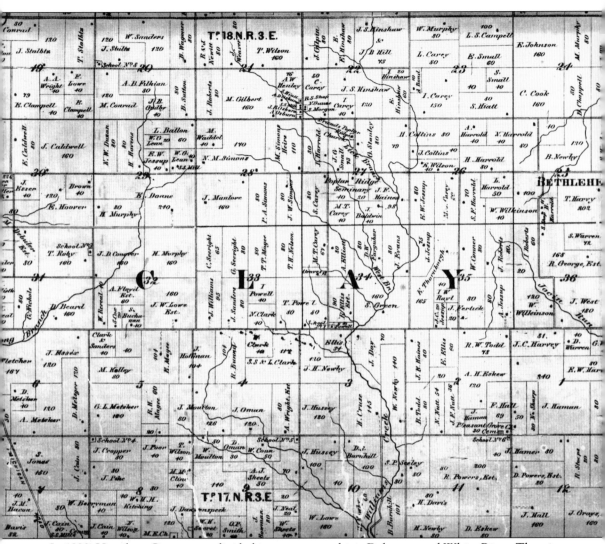

In 1823, Hamilton County was divided into two townships, Delaware and White River. Then in 1833 these were subdivided into nine townships, with Clay Township being one. This map also dates to 1866. (Courtesy of the Hamilton County surveyor's office.)

Pres. Andrew Jackson's signature was on the original land deed for the Bethlehem founders in 1836. The 1889 deed shown above was for the Hawkins family and reflects the town's subsequent name change to Carmel. (Courtesy of the office of the clerk-treasurer.)

The original plat of the town Bethlehem in 1837 consisted of 14 lots on the intersection to two dirt roads. These plats followed a straight line down Main Street, now Range Line Road. The Main Cross Street, now Main Street, bisected the platted area with Gold Alley and Vine Alley included. Recording the plat were Daniel Warren, Alexander Mills, John Phelps, and Seth Green. The purchases and claims of the area surrounding Carmel in 1866 are shown here. (Courtesy of the Hamilton County surveyor's office.)

Three of the earliest residents living in the Carmel area are pictured here during the town's centennial celebration. They were, from left to right, John Stanton, 80 years of age at the time of photograph; John A. Haines, 88; and Frank Williamson, 92. All three lived most of their lives in the area. (Courtesy of Phil Hinshaw.)

White Chapel Church is the only pioneer church remaining in the township. The church's construction began in 1850 in a small nearby town called Mattsville, which has since been annexed by Carmel. At the time of the church's first service, an outstanding debt for $14 was owed. The congregation raised the money at the first service. (Courtesy of Phil Hinshaw.)

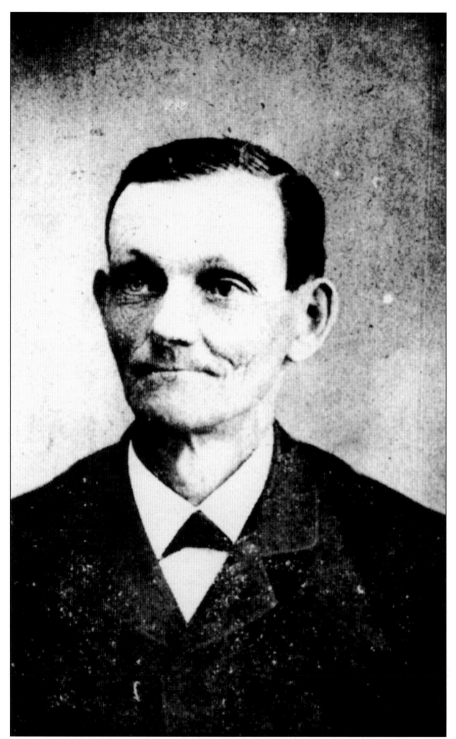

As a young child, Zina Warren traveled with his father, Daniel, to settle in this area. Born in 1831, Zina lived in Carmel until his death in 1911. He served the community in many ways, including being among its first postmasters. (Courtesy of the Carmel Clay Historical Society.)

Reminiscences of the Long Ago

by Zina Warren 1831-1911

A HISTORY OF EARLY CARMEL REPRODUCED FROM THE ORIGINAL BY THE CARMEL BICENTENNIAL COMMISSION IN HONOR OF THE 200TH ANNIVERSARY OF THE NATION'S BIRTH

Another of Warren's contributions was his book *Reminiscences of Long Ago* about his recollections of his family and life in Carmel. One of his passages describes the early community as one where "droves of hungry wolves could come up of nights with their dismal howling." The book was published in 1911 just after his death and reissued in the late 20th century. (Courtesy of the Carmel Clay Historical Society.)

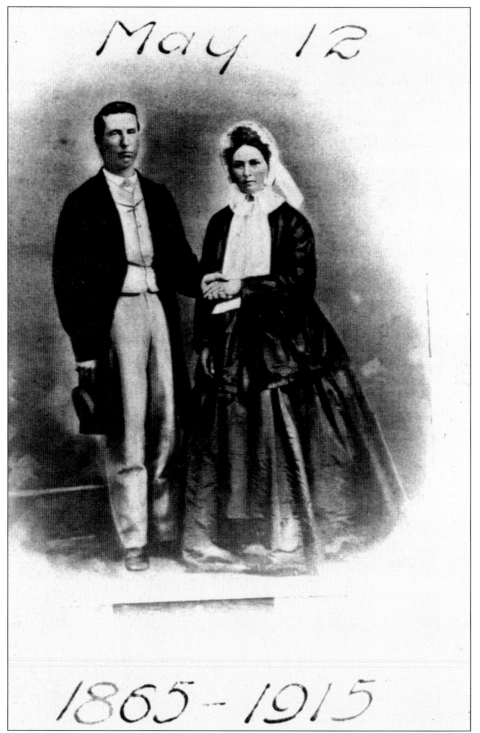

The Carey family was among Carmel's early settlers. In fact, some members of the Carey clan are credited with erecting the county's first flour mill in 1865. Pictured here are Lemeul and Rose Coffin Carey on their wedding day, May 12, 1865. (Courtesy of the Carmel Clay Historical Society.)

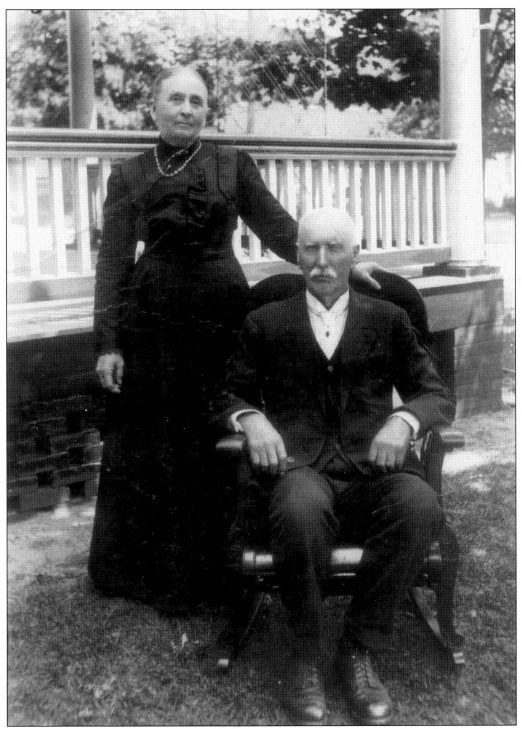

Lemeul and Rose Carey remained within the community. They are pictured here in front of their house at 211 North Range Line on their 50th wedding anniversary in 1915. Lemeul died in 1922 with Rose following in 1936. (Courtesy of the Carmel Clay Historical Society.)

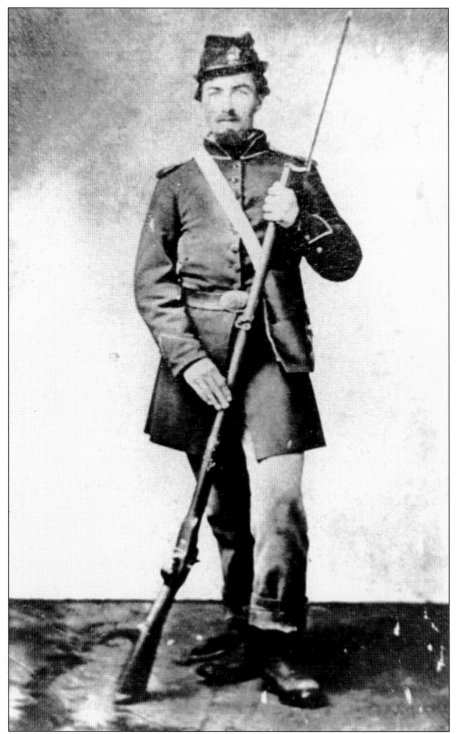

During the Civil War, almost 100 of the township's boys signed up for military service. Most aligned with the northern troops, like this unidentified solider. About seven, however, chose the Confederacy. (Courtesy of the Carmel Clay Historical Society.)

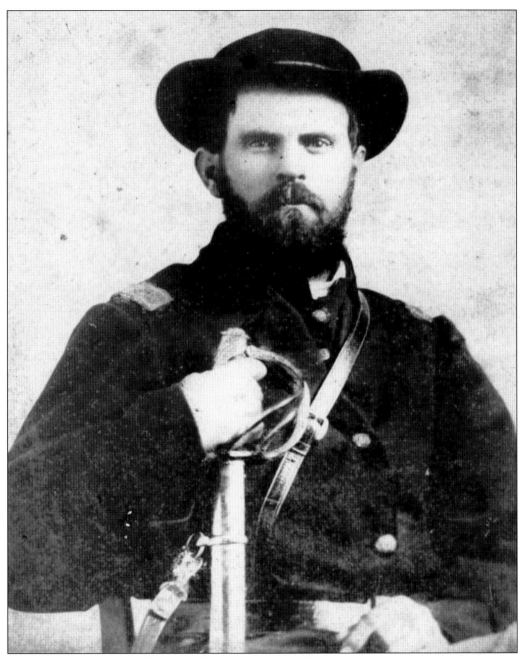

One volunteer serving in the state's Home Guard, the successor to the state militia, was Jeremiah Oakley Pursell, who was 35 years old at the time of this photograph. Although Pursell lived in Broad Ripple, his family was from Carmel. Many Civil War veterans are buried in the Carmel, Poplar Ridge, White Chapel, and Farley Cemeteries. (Courtesy of the Carmel Clay Historical Society.)

During the early to mid-1800s, the Underground Railroad ran its invisible track through Hamilton County to hide runaway slaves. The network of antislavery activists kept members' names and hide-away locations a secret. It is well-documented that members of the Quaker religion—many of whom lived in Carmel—were active in this organization. One of those was Asa Bales, who lived in Westfield and directed the regional network. His gravestone is found in the Anti-Slavery Cemetery in nearby Westfield. (Courtesy of the Carmel Clay Historical Society.)

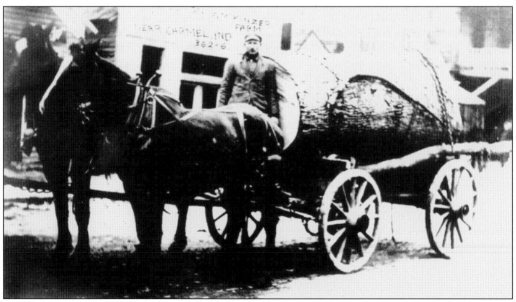

Like many of the farms in central Indiana, those in Carmel also had to be cleared of many trees for level fields of crops. Here is pictured one of the last virgin timbers cut in the area hauled away from the William Kinzer farm. This giant log was hauled by Jeff Reese during the early 1900s. (Courtesy of the Carmel Clay Historical Society.)

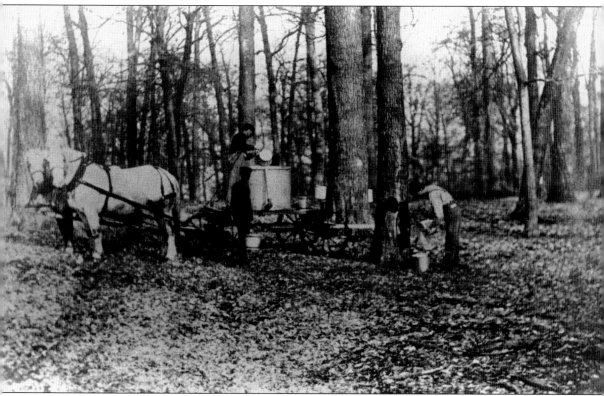

Sugar camps were plentiful in the area because of the abundance of maple trees. Here one of the farm hands on the Kinzer farm is drawing sap. Tapping the trees usually started in late January and lasted until about mid March. It is believed that Wesley Williamson owned the last sugar camp, near 116th Street and Gray Road. (Courtesy of the Carmel Clay Historical Society.)

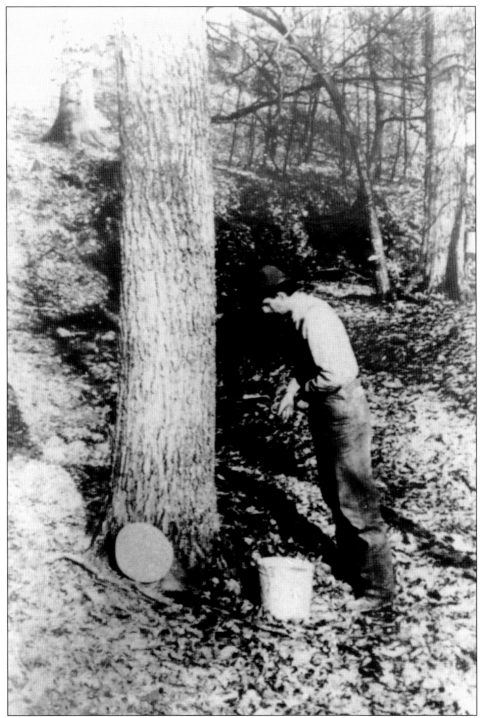

Farmers had to wait for the right weather conditions in order to tap the trees. For the sap to run, the nights had to be cold, ideally in the mid-20s. Below freezing, the sap would take too long to warm up the next morning and not flow well. Too warm, the sap would not run either. (Courtesy of the Carmel Clay Historical Society.)

Sharing Clay Township with Carmel is the unincorporated town of Home Place. Settlers first arrived in Home Place, originally known as Pleasant Grove, in 1825. A school and the Pleasant Grove Church were established in this area in 1832. The town of Home Place was officially platted in 1914 with two additional plats in 1916. (Courtesy of the Home Place Library and Museum.)

One of the first cemeteries in Clay Township was the Pleasant Grove Cemetery (now on the northeast corner of 106th Street and Broadway Street). The first interment was that of Elizabeth S. Hamar, the two-year-old daughter of James and Anna Hamar in February 1837. (Courtesy of the Carmel Clay Historical Society.)

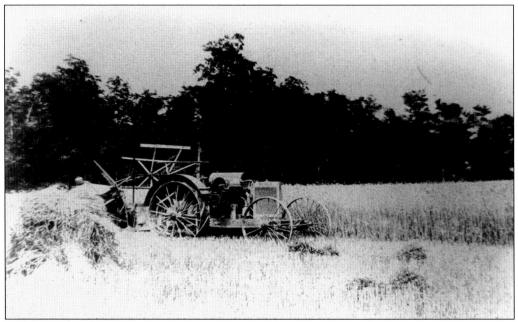

Thrashing machines or, in modern spelling, threshing machines (or simply thresher), were first seen in Hamilton County in 1841. The device was first invented by Scottish mechanical engineer Andrew Meikle in about 1784. (Courtesy of the Carmel Clay Historical Society.)

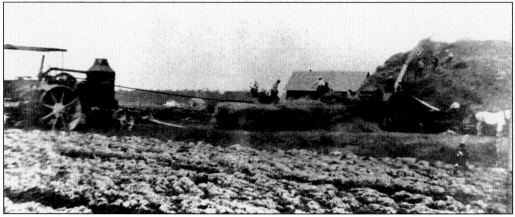

The purpose of the thrashing machine was to eliminate the laborious and time consuming process of separating grain from stalks and husks by hand. Modern-day combine harvesters operate on the same principles and use the same components as the original threshing machines built in the 19th century. (Courtesy of the Carmel Clay Historical Society.)

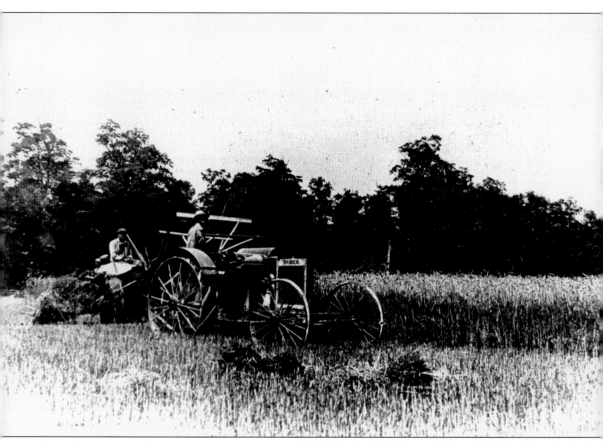

In addition to the Kinzers, many generations of families operated farms. Names like Capertons, Greggs, Frenzels, and Whites have been heard and seen in Carmel for generations. (Courtesy of the Carmel Clay Historical Society.)

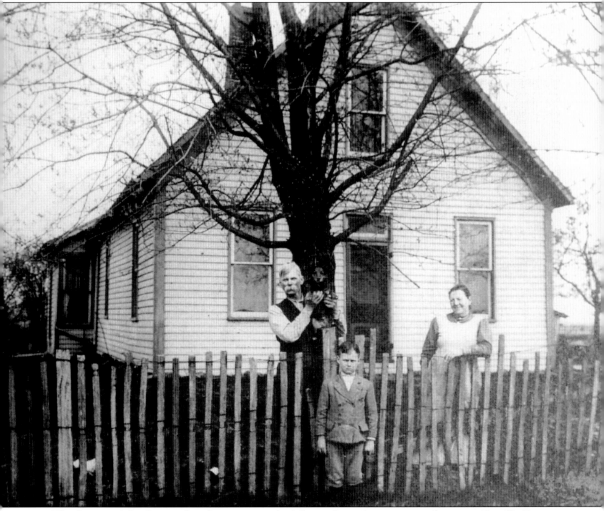

The house of the Brown family was typical of the early architecture in the area. Orville Brown, pictured as a young boy here, was a lifelong resident of the area. He was born in 1902 and died in 1934. (Courtesy of the Carmel Clay Historical Society.)

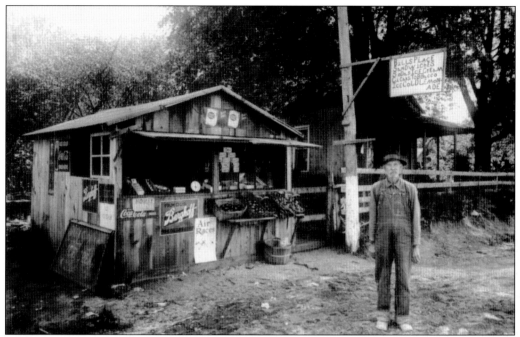

William Huffman ran Bill's Place around the early to mid-1920s near 110th Street and Westfield Boulevard, which once served as a toll road known as the Indianapolis Westfield Pike. Huffman was the tollgate keeper as was his father-in-law, Charles Michener, before him. (Courtesy of the Carmel Clay Historical Society.)

Farming in the 1940s continued to be the area's primary form of business. The cattle shown here were on a farm along the southside of 106th Street in Clay Township. Subdivisions of housing arrived in the early 1960s. (Courtesy of the Home Place Library and Museum.)

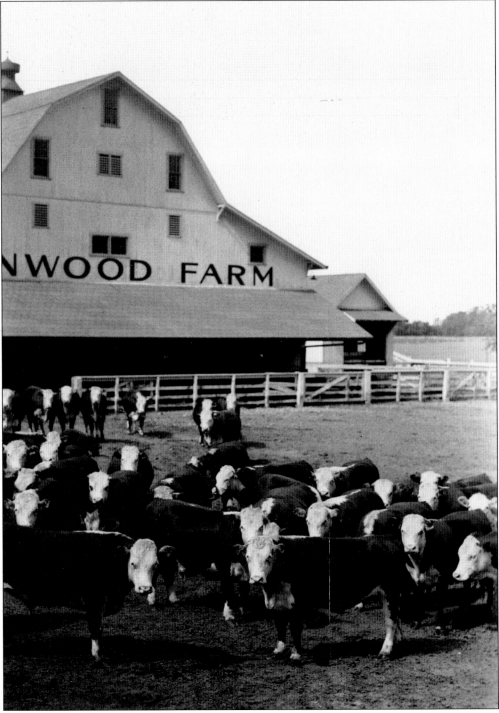

Lynnwood Farm, about four miles east of downtown Carmel, was once comprised of more than 500 acres and was considered one of the showplaces of Indiana. Owner Charles Lynn purchased the land in the early 1930s and hired local contractor Bud Applegate to build all the main barns. (Courtesy of Agriculture Communications, Purdue University.)

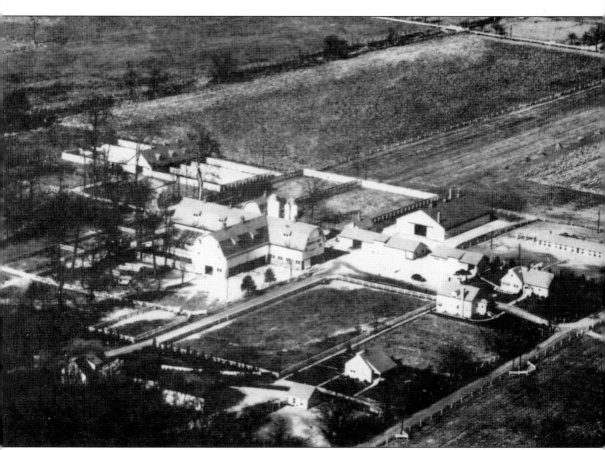

Although he also worked as an executive for Eli Lilly and Company, Lynn became nationally known for breeding Percheron horses, Hereford cattle, and Berkshire hogs. He donated the farm, shown here in an aerial view, to Purdue University in 1942. (Courtesy of Phil Hinshaw.)

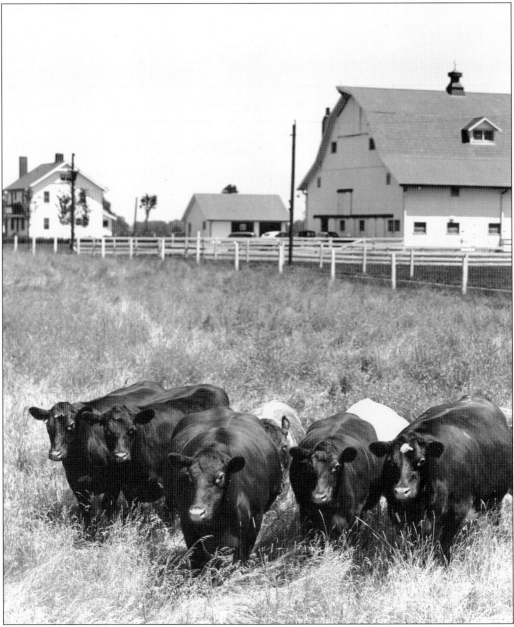

In addition to the Lynnwood Farm, there have been other large, showcase farms in the area. Some include the Cricklewood Farm, Happy T Farm, Senator Farm (which was closely connected with world track record holder Greyhound and driver, Sep Palin), Gregg Farm, Hobby Horse, and White Haven. (Courtesy of Agriculture Communications, Purdue University.)

Two

Along the Monon

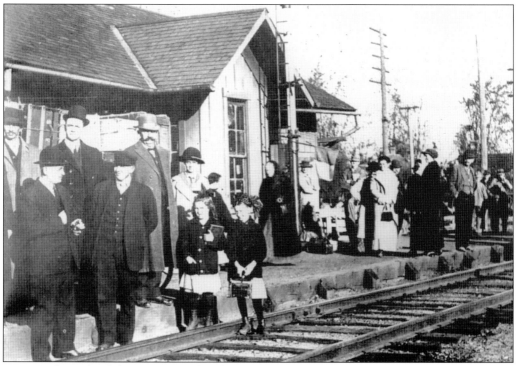

In 1882, the rails of the Monon Railroad were laid through Carmel with the depot opening in 1883. At one time, the Monon Railroad depot was a hub of activity in Carmel. Pictured here are members of the Carmel Hunting Club during the railroad's heyday waiting for the train taking a northern route that led all the way to Chicago. (Courtesy of the Carmel Clay Historical Society.)

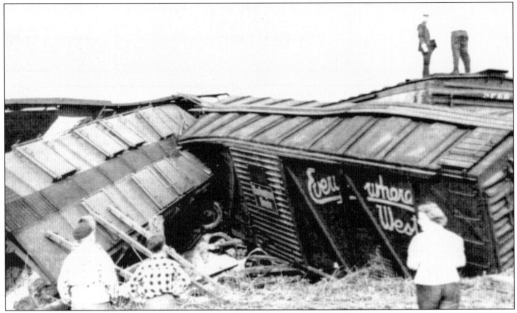

Along with increased efficiency of the railway system, some setbacks occurred as well, such as some of the area's train wrecks, illustrated here with photographs from the 1950s and 1960s. One accident that gathered great notoriety occurred in December 1906 where Main Street crosses the track. Henry and Avis Henley's buggy had a screen fastened all the way around so they could not hear the train coming. Their buggy collided with the 8:00 a.m. mail train. A couple of days later someone found Henry's watch sitting on top of the grist mill, about 30 feet high; it was still running. (Courtesy of the Carmel Clay Historical Society.)

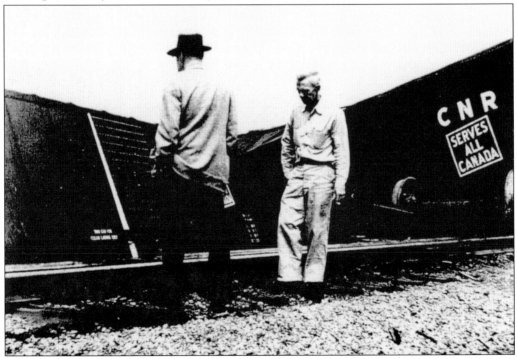

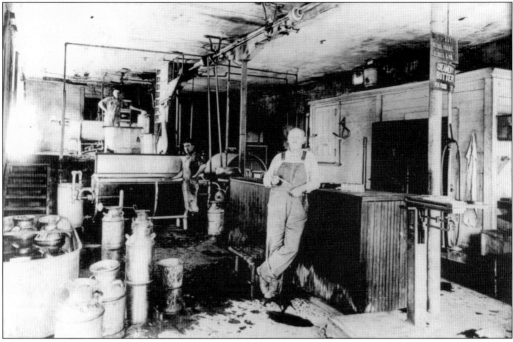

The railway system and the area's farming efforts helped other businesses as well, such as the Carmel Days Creamery located along the Interurban tracks in the early 1900s. Pictured is an interior shot of the creamery. (Courtesy of the Carmel Clay Historical Society.)

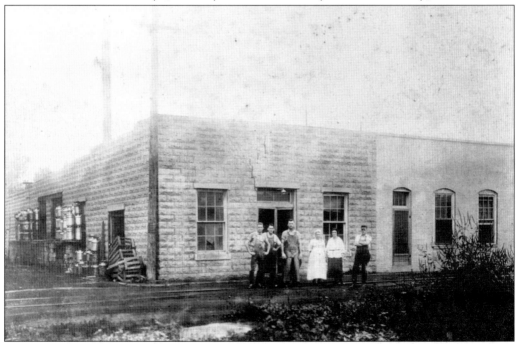

This exterior shot of the Carmel Days Creamery shows some of the company's employees, which included Albert Moon and Richard Moon. The woman in the white dress is Kate McDonald. (Courtesy of the Carmel Clay Historical Society.)

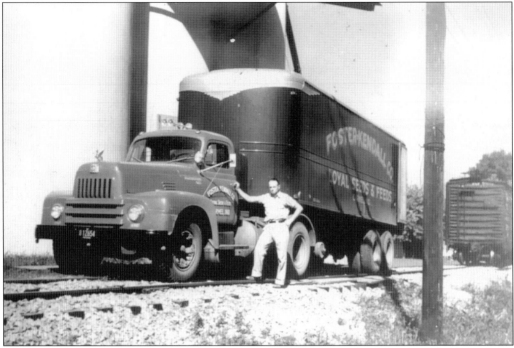

In 1929, Foster Kendall Corporation organized and purchased the Cooperative Elevator. The elevator was situated next to the Monon Railroad for easy access to boxcars, which workmen filled with the area's harvested grain. By 1962, the elevator was still a viable business. As the railway system dwindled, so did activity at the elevator. (Courtesy of the Carmel Clay Historical Society.)

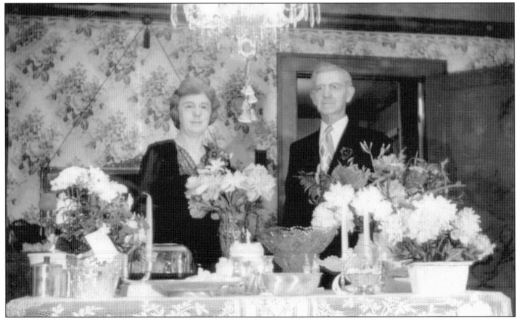

During the early to mid-1900s, Leo Long served as the town's railroad depot agent. Long is pictured here with his wife, Edna, on their 25th wedding anniversary. (Courtesy of the Carmel Clay Historical Society.)

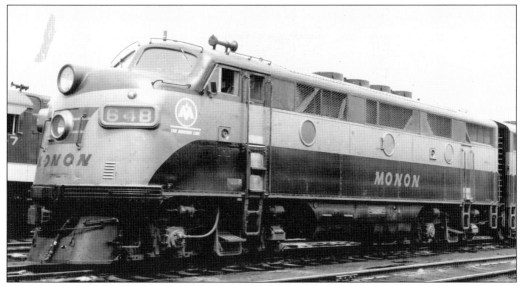

A severe financial downturn brought the Monon Railroad to near bankruptcy before World War II. Transporting war materials and military service personnel, however, provided an upswing in profits. After the war, the Monon Railroad was reportedly the first railroad in the nation to replace all its steam locomotives with diesel powered ones, such as the one pictured here in 1956. (Courtesy of the Carmel Clay Historical Society.)

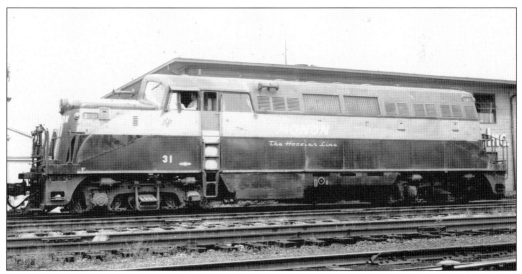

By 1957, passenger train business dwindled significantly to a few people a day. Although passenger service was almost nonexistent, freight trains, like this one in 1960, kept the station alive. It was a time when the railroads were the fastest and least expensive way to move goods. (Courtesy of the Carmel Clay Historical Society.)

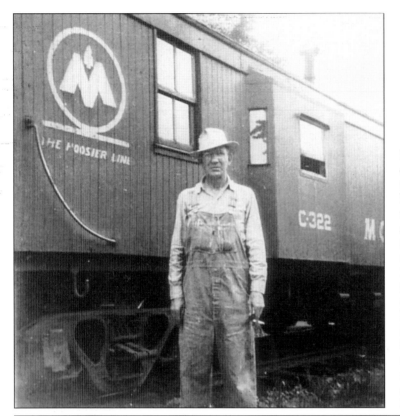

Freight service continued through the 1960s. By then, however, companies were beginning to see the financial advantages of truck and air shipping. In 1971 the Monon was merged into a larger conglomerate. Pictured here in the 1950s is long-time brakeman George Moorhaus with some of his coworkers. (Courtesy of the Carmel Clay Historical Society.)

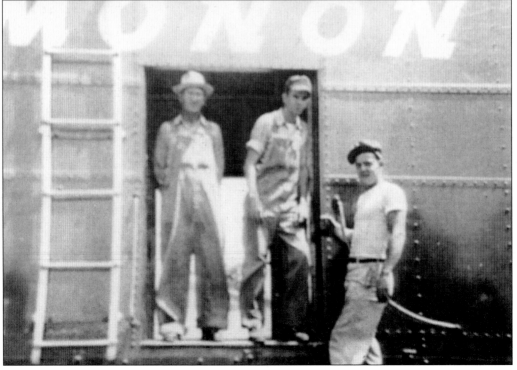

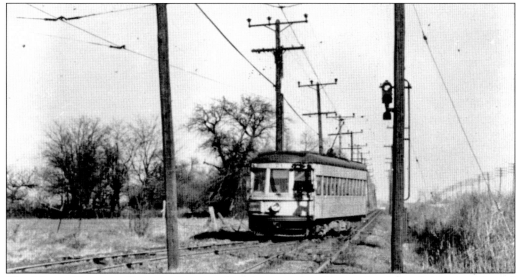

The Union Traction Company's interurban line ran its electrical overhead wires in Carmel from 1903 to 1938. The company's lines ran a parallel course by the Monon Railroad tracks. (Courtesy of the Bass Photo Company Collection, Indiana Historical Society.)

UNION TRACTION COMPANY OF INDIANA

UNION TRACTION

Traffic Department.

Arthur W. Brady, President.
H. A. Nicholl, Gen. Manager.
S. R. Dunbar, Purchasing Agent.
C. S. Keever, Act. Supt. Transportation.
G. H. Kelsey, Electrical Engineer.
R. N. Hemming, Supt. Motive Power.

General Offices, Anderson, Indiana.
W. H. Forse, Jr., Secretary and Treasurer.
Walter Shroyer, Auditor.
E. E. Slick, Claim Adjuster.
J. A. Van Osdol, General Attorney.

C. H. Allen, Real Estate and Tax Agent.
L. A. Mitchell, Engineer Maintenance of Way.
F. D. Norviel, Gen. Pass. and Frt. Agent.
M. E. Graston, D. P. and F. Agt., Indianapolis.
C. O. Balfour, Freight Claim Agent, Indianapolis.

MARION FLYER	MUNCIE METEOR	INTERURBAN MILEAGE			
INDIANAPOLIS—ANDERSON—MARION	INDIANAPOLIS—NEW CASTLE—MUNCIE	Divisions	Mil	Divisions	Mil

North Bound		South Bound	West Bound		East Bound	Indianapolis—Muncie	57	Anderson—Middletown	10		
Read Down		Read Up	Read Down		Read Up	Indianapolis—Kokomo	57	Anderson—Wabash	53		
		STATIONS			STATIONS	Indianapolis—New Castle	63	Muncie—Bluffton	29		
5 00	10 00	Lv Indianapolis Ar	9 50	3 50	8 00	Lv.. Muncie ..Ar	6 50	Kokomo—Logansport	23	Muncie—Union City	33
6 18	11 18	Anderson	8 38	2 38	8 32	New Castle	6 18	Kokomo—Peru	23	Muncie—Portland	32
7 40	12 40	Ar.. Marion ..Lv	7 20	1 20	9 50	Ar Indianapolis Lv	5 00	Tipton—Alexandria	20	Total length of Line	410

The interurban, defined as "a railway having less than half of it within a municipality's limits," allowed Carmelites to travel to Indianapolis in about 42 minutes. A ticket to ride in 1926 cost a minimum of 50¢. (Courtesy of the Carmel Clay Historical Society.)

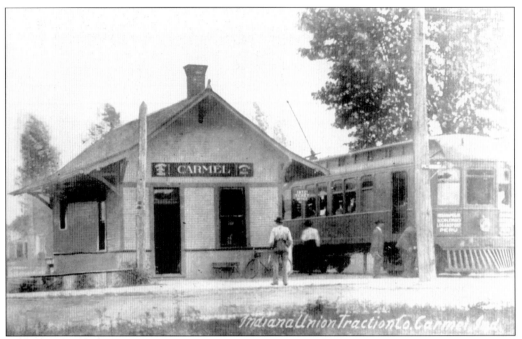

The interurban line also had its own depot on Main Street, about two blocks northeast of the Monon Railroad depot. The Union Traction and Monon tracks crossed paths at about 111th Street, with the interurban eventually heading northeast and the railroad going northwest. (Courtesy of the Carmel Clay Historical Society.)

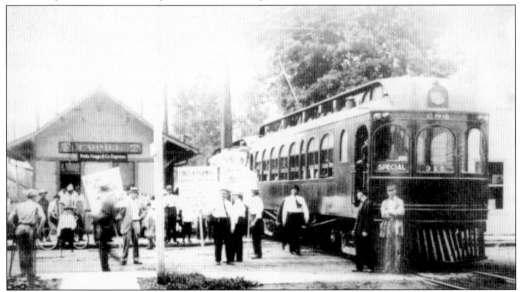

In 1914, a group of automobile enthusiasts gathered at the depot for a trip to lobby the Lincoln Highway Association. The association was planning the first transcontinental road, called the Lincoln Highway, across the United States. Civic groups throughout the country tried to sway the association to route the highway through their communities in an effort to improve the roads. The association chose a northern route through Indiana. (Courtesy of the Carmel Clay Historical Society.)

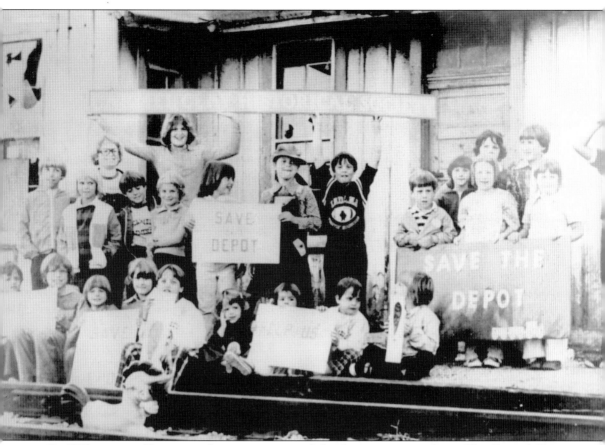

By 1975, train traffic was nearly nonexistent, and the depot in serious decay. The Carmel Clay Historical Society took action to save the depot and invited the community to support the effort. Today the former depot has been renovated and holds a small museum operated by the society. (Courtesy of the Carmel Clay Historical Society.)

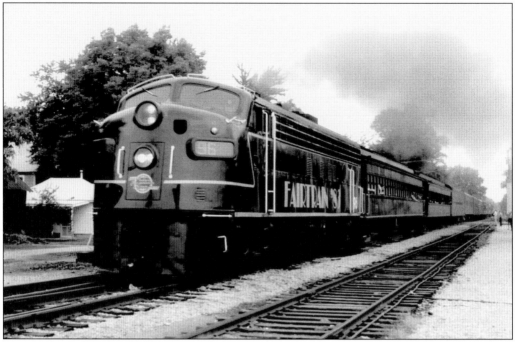

The tracks were not completely abandoned in the early 1980s, however. From 1983 to 1985, the Indiana State Fair Train made a few trips to take Hamilton County residents to the fair. Today the fair train operates a route from Fishers to the fair. (Courtesy of Mike Wannemacher.)

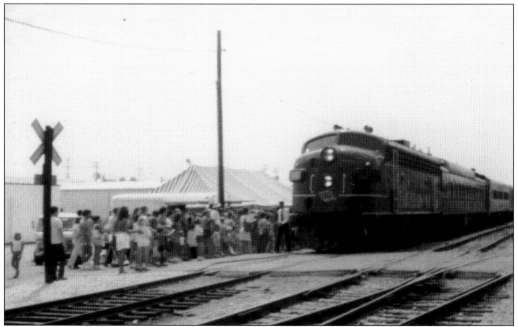

After a final train to haul equipment for installing a fiber optic cable in the right-of-way, the tracks were pulled up in 1987. By 2000, plans were drawn for a new use of the former train route—a recreational path linking Carmel to Indianapolis and other sections of Hamilton County. (Courtesy of the Carmel Clay Historical Society.)

Three

ABOUT TOWN

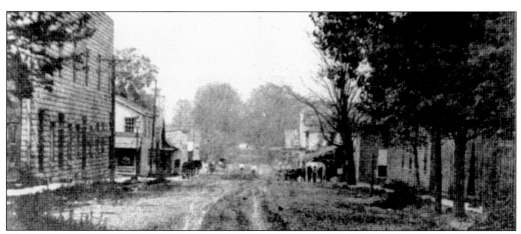

The streets of Carmel during the first 150 years of its existence were crude and filled with potholes. Most were just dirt and mud, with a gravel blacktop for the primary roads. This shows the view looking west on Main Street in 1908. (Courtesy of Phil Hinshaw.)

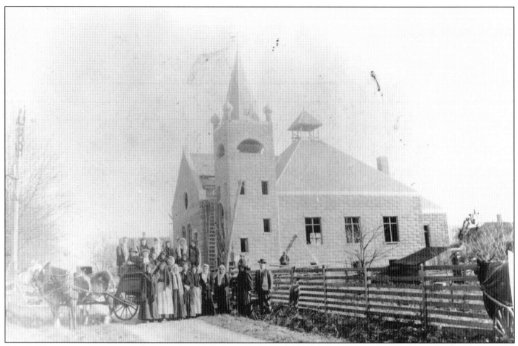

In 1905, construction on the Methodist church on Second Street Southeast began. Here a group of parishioners gathered in front of the newly completed structure. (Courtesy of the Carmel Clay Historical Society.)

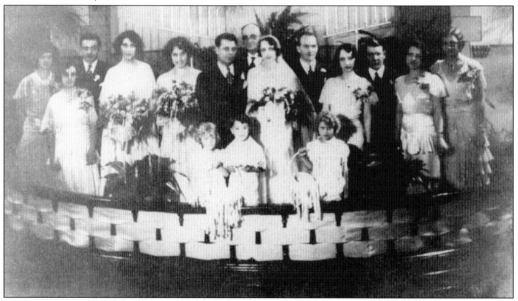

This wedding photograph, dated around 1930, shows an interior view of the Methodist church. Those in the wedding party included, from left to right, (first row) Helen Watts, Jack Bailey and Dorothy Richardson; (second row) Ethel Horton, Lois Myers Thomas, Eldred Myers, Anna Feaster, Elsie George, Harold Gerrard (groom), Rev. Victor Hargitt, Juanita L. Gerrard (bride), Lowell Myers, Vera Deardorff, Frank Thomas, Vivian Blankenbaker, and Opal Dawson. (Courtesy of Phil Hinshaw.)

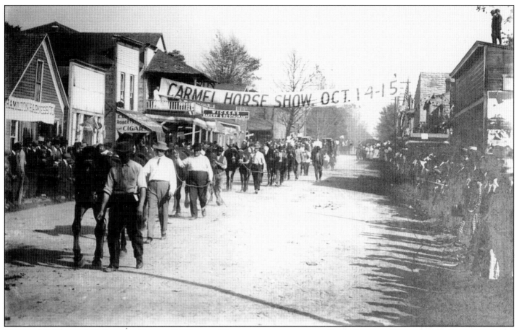

From 1907 to 1916, the Carmel Horse Show was an annual tradition. Every fall, hundreds of visitors descended on the town's tree-lined streets for a cavalcade of equine competitions. At the time, several local farms raised horses. (Courtesy of the Carmel Clay Historical Society.)

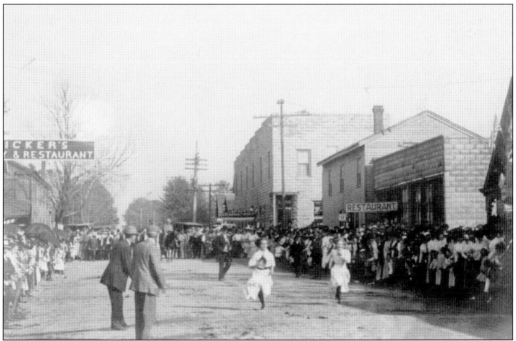

The horses were not the only breathing beings competing during the Carmel Horse Show. The photograph above shows a foot race as part of the activities. Each year new attractions were added. One year, the event even extended over four days. (Courtesy of the Carmel Clay Historical Society.)

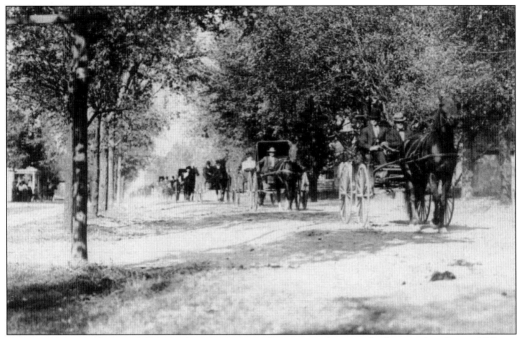

From early morning until late in the evening, "streets were thronged" during the Carmel Horse Show, according to one newspaper account. According to one writer, the show was reminiscent of the old county fair, which "was the event of the year in the county. Friends who never met at any other time met annually at your fair." (Courtesy of the Carmel Clay Historical Society.)

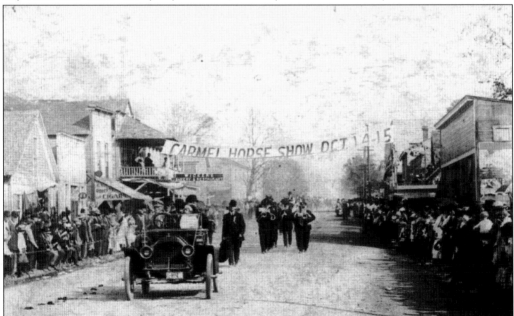

The first automobile led the Carmel Horse Show cavalcade in 1911. The car serves as a sign of the end of the horse age and the beginning of the country's fascination and reliance on the automobile for transportation. This car also predates the American standard adopted before 1920 of placing the driver's side on the left. (Courtesy of the Carmel Clay Historical Society.)

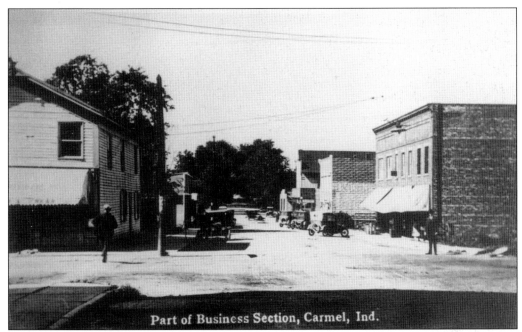

Part of Business Section, Carmel, Ind.

By 1910, city residents realized the deplored state of their roads and decided to make improvements. During that year, a downtown street was paved with brick. In 1922, East Main Street was paved with concrete; the west side completed in 1924. (Courtesy of the Carmel Clay Historical Society.)

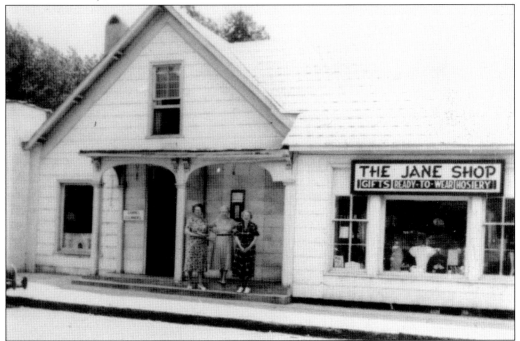

By the early 1950s, the streets easily accommodated patrons of the Jane Shop on West Main Street. Pictured are, from left to right, Rose Graves, Mildred Featherson, and Jane Haines, owner of the shop. (Courtesy of the Carmel Clay Historical Society.)

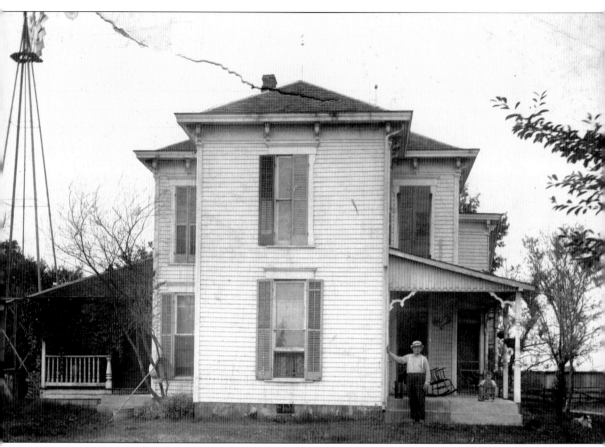

In about 1913, J. W. Johnson posed outside his home on the outskirts of Carmel on Spring Mill Road when he was about 57 years of age. Posing with him is his grandson J. Arnold when he was one or two years of age. One of their descendents was long-time resident Mildred Johnson Carey. (Courtesy of the Carmel Clay Historical Society.)

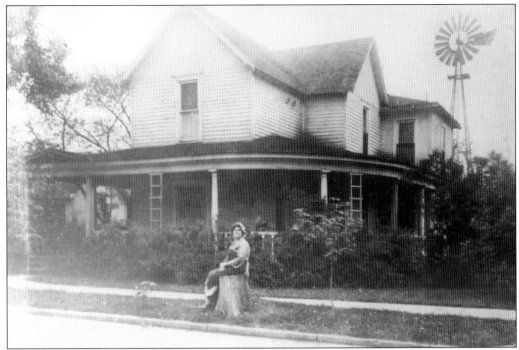

By the time Elzina (Furst) Feaster posed in front of her house at 420 North Range Line Road in the late 1920s, Carmel homes had access to electricity for only about 20 years. Electrical lines arrived in Carmel in 1904. (Courtesy of the Carmel Clay Historical Society.)

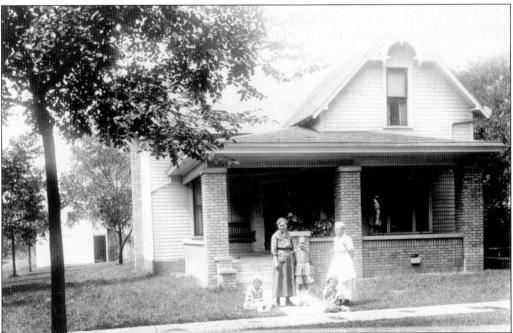

Near Feaster's house was the home at 210 North Range Line Road. Pictured in 1920 out front are, from left to right, Sarah Clark, Mary Davis, Virginia Davis, Wilma Cox, and Keith Cox. (Courtesy of the Carmel Clay Historical Society.)

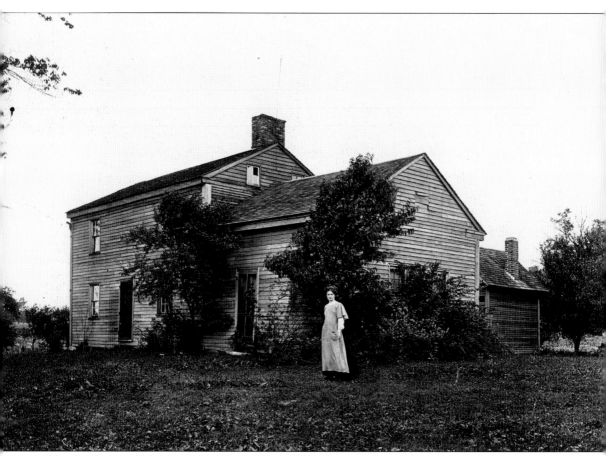

The first home of Mr. And Mrs. Edward Samuel Hopkins was located on the southeast corner of 131st Street and Towne Road. Posing out front is Mabel Weaver Hopkins in 1907. (Courtesy of the Carmel Clay Historical Society.)

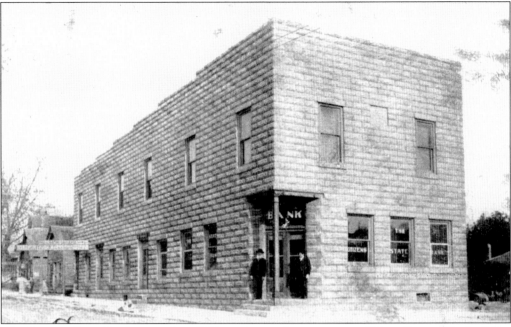

The Citizens State Bank opened in 1905 on the northwest corner of Main Street. The building contractor used cement blocks manufactured in Carmel by Myers Block Company. The Odd Fellows Lodge used the building's second floor for its meetings. The bank, like many others during the Great Depression, closed in 1929. (Courtesy of the Carmel Clay Historical Society.)

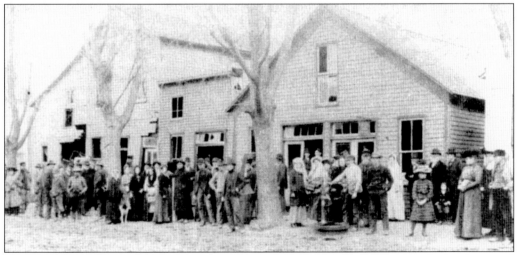

On March 31, 1904, an explosion caused by a gas leak damaged a grocery, barbershop, and woodworking shop on the north side of West Main Street (seen on the left side of the photograph). This explosion caused all gas users to be metered a new rate of 25¢ per 1,000 cubic feet of gas. (Courtesy of Phil Hinshaw.)

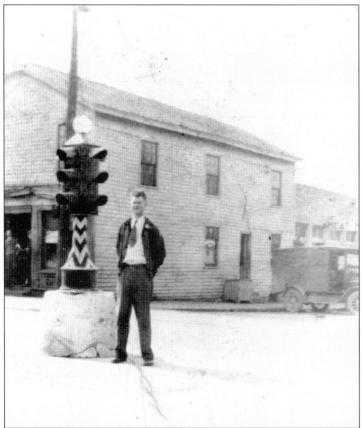

One of the country's first documented traffic signal lights was installed in Carmel in 1924 at the corner of Main Street and Range Line Road. Pictured here is a refined version (around 1929) with Kenneth Reeves, a student crossing guard, on duty. According to one news report, it "proved a bonanza for local law enforcement officials and caused the Hoosier Motor Club to route tourists around Carmel to avoid the speed trap and traffic hazard." (Courtesy of the Carmel Clay Historical Society.)

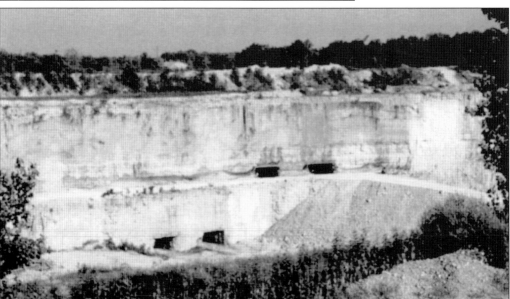

Limestone deposits have proven to be another avenue of revenue for Carmel residents. Several individuals and businesses have operated small to large quarries for profit. Most of these quarries have been reclaimed. In fact, Founders Park and Flowing Well Park used to be quarries.

Carmel resident Leslie Haines designed and built Carmel's first signal light. The device's switch circuit control device eliminated the need for an expensive motor. An original is on display today at the Carmel Clay Historical Society's museum. (Courtesy of the Carmel Clay Historical Society.)

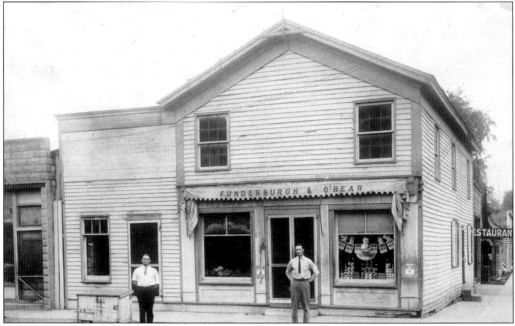

In 1922, the Sunderburgh and O'Rear grocery was one of the businesses serving the area. It was located on the southwest corner of Main Street and Range Line Road. Pictured above are Shorty O'Rear on the left and Donald Hobbs on the right. (Courtesy of the Carmel Clay Historical Society.)

Entering the north side of the Sunderburgh and O'Rear grocery around 1920 was Mary Reese Lawrence (on right) and an unidentified friend. Lawrence was the mother of Phyllis Lawrence Morrow, the fifth generation of the family living in this area. Phyllis's great-great-grandfather was a member of the Underground Railroad. (Courtesy of the Carmel Clay Historical Society.)

The first librarian of the Carmel Public Library was Sarah Follett Walker. Another local person who influenced the library was the architect Austin Bond. Today's library, opened in 1990, was ranked second in a 2003 nationwide survey of public libraries. (Courtesy of the Carmel Clay Historical Society.)

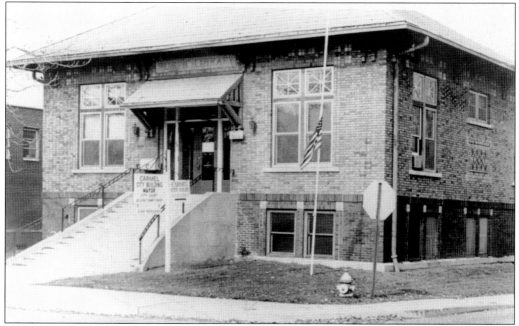

The Carmel Public Library was built in 1913, funded by a grant from the Carnegie Foundation. The building became the city hall and court in 1972, after a new library was erected a few blocks east. Today the 1913 building has been renovated to serve as a restaurant. (Courtesy of the Carmel Clay Historical Society.)

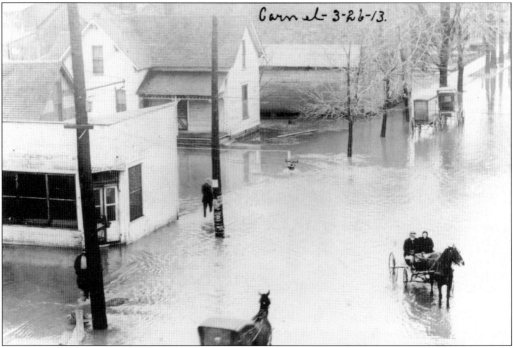

The year 1913 proved to be disastrous for Carmel. A flood, which covered much of Indiana and Ohio, left its mark. In some parts of Hamilton County, the water reached over three feet high. The year also saw a major fire, which destroyed many of the town's businesses. (Courtesy of the Carmel Clay Historical Society.)

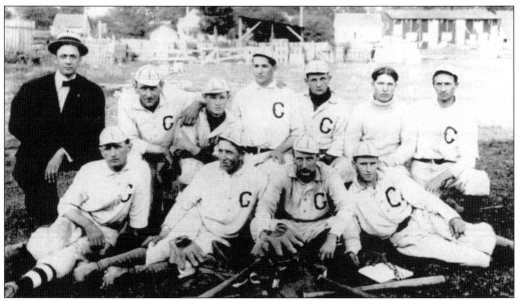

Helping to lift the spirits of some of those affected by the 1913 disasters was the town's independent baseball team. The baseball diamond was located on the corner of Second Street and Second Avenue Southwest. (Courtesy of Phil Hinshaw.)

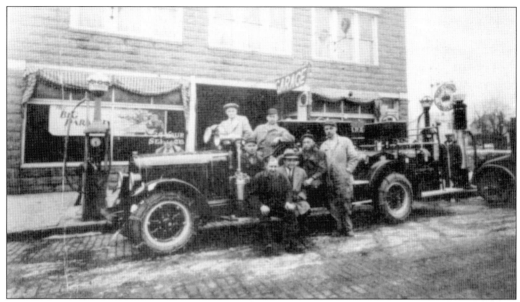

In 1927, Carmel and Clay Township jointly purchased the area's first fire truck. Identified here are Edgar Cotton, Elmer Strattan, Rue Hinshaw, John Parsley, Alvin "Popcorn" Brown, Claude Major, Arlie Eskew, Earl "Dutch" Sanders, and Harry Snipes (at the rear of the truck). (Courtesy of Phil Hinshaw.)

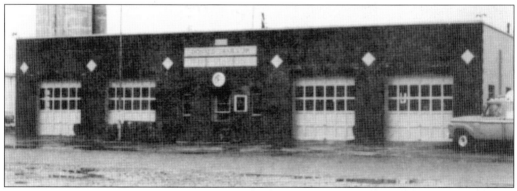

In the 1920s, the volunteer fire department operated out of the Carmel Garage, which was open 24 hours a day. Rue Hinshaw was the first fire chief. Slowly enough funds were gathered to build the Donald Swails Memorial Station, which was built primarily for the purpose of storing fire equipment. (Courtesy of Phil Hinshaw.)

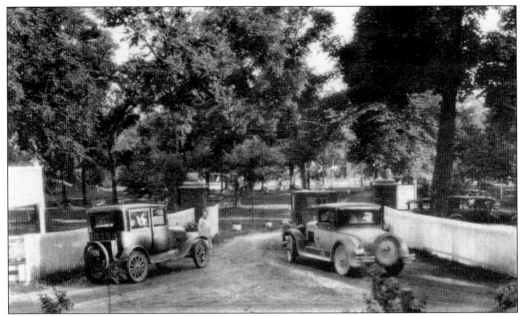

Located along the banks of White River, Northern Beach continued to draw visitors in the 1930s from around the area for a day of outdoor recreation. The facility was purchased in 1993 by its current owner and is available for rental. (Courtesy of the Carmel Clay Historical Society.)

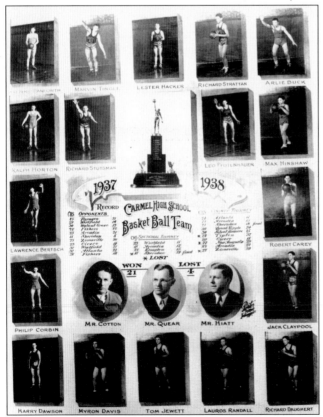

By 1938, the town had grown to about 770 people. One of the town's sources of pride and spectator enjoyment was the high school's basketball team. At the time, the team probably played before a graduating class of about 21. Carmel students were introduced to basketball in about 1902. (Courtesy of the Carmel Clay Historical Society.)

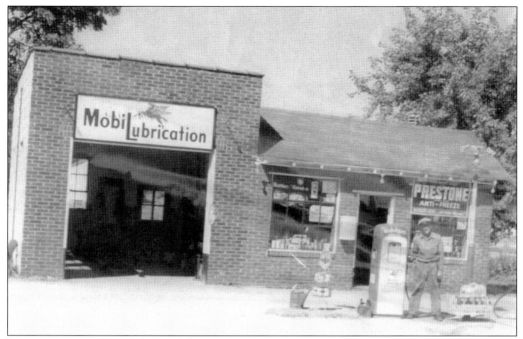

Martin Carey operated the Mobil Filling Station during the 1940s on the site of the first log schoolhouse. Carey's structure remains on the southwest corner of Range Line Road and Smokey Row Road. (Courtesy of the Carmel Clay Historical Society.)

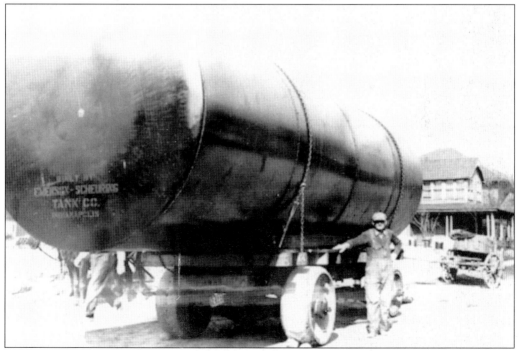

In the early 1900s, Jess Reese helped install an underground gas tank for one of the area's first service stations. Kenton Smith operated the station at the intersection of Main Street and Range Line Road. (Courtesy of the Carmel Clay Historical Society.)

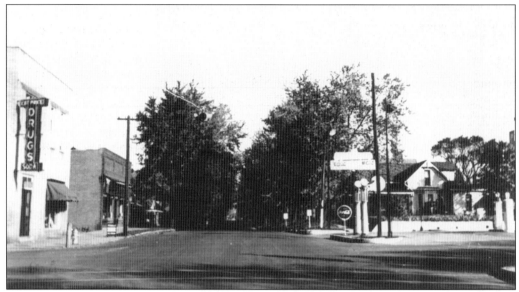

Above is the view looking north on Range Line Road around 1946. Brown's Drug Store, on the left, provided a popular gathering spot for many of the area's residents. Owner John W. Brown opened his operation in 1938 in a location that had served as a pharmacy since 1865. (Courtesy of the Carmel Clay Historical Society.)

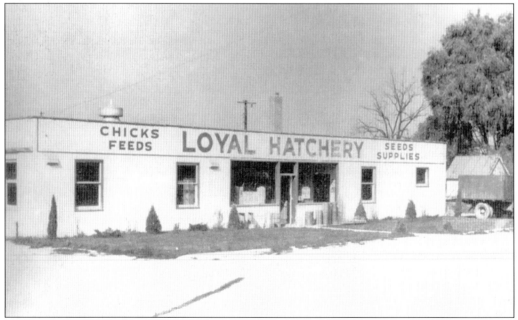

Loyal Hatchery was another local business depending on a rural economy. Pictured here in the 1950s, Loyal Hatchery offered a complete line of poultry, dairy, and hog feeds, along with the Loyal Hatchery–brand baby chicks. (Courtesy of Carmel High School.)

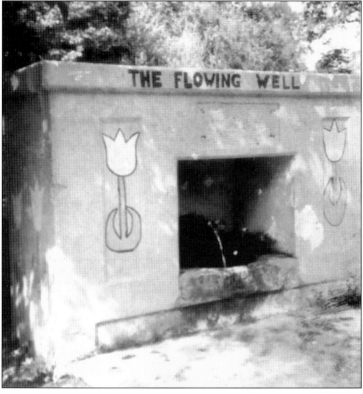

Although Joe Carey failed to find the natural gas in his original drilling effort in 1902, he did discover a natural underground reservoir of spring water. As late as the 1970s, people as far away as Chicago would come to Carmel just to drink the water of the Flowing Well built in 1926. (Courtesy of the Carmel Clay Historical Society.)

When the concrete structure housing the well became dilapidated, a new gazebo and small park were built in the late 1970s to replace the original. One of the new structure's features is a plaque honoring nine of Carmel's first settlers. Today some reports indicate that about 250,000 people visit Carmel's Flowing Well. (Courtesy of the Carmel Clay Historical Society.)

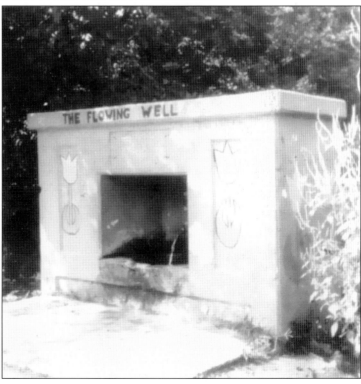

In 1874, Carmel was incorporated as a town and remained that way until 1974, when residents voted to make Carmel a fourth class city. In 1975, the first city primary took place, and Albert Pickett, a 1936 graduate of Carmel High School, became the town's first mayor (pictured left). At the time, the population was about 13,500. The last town board members were Bill McFadden, Fred Swift, Stan Beach, Phil Hinshaw, George Stevens, and clerk-treasurer Peggy Smith. (Courtesy of the office of the Mayor of Carmel.)

In 1976, the official seal of the City of Carmel was adopted and was nearly the same as the town's seal. A significant difference, however, was changing the word "town" to "city." Historians believe that the seal was designed sometime during the era of the area's natural gas boom.

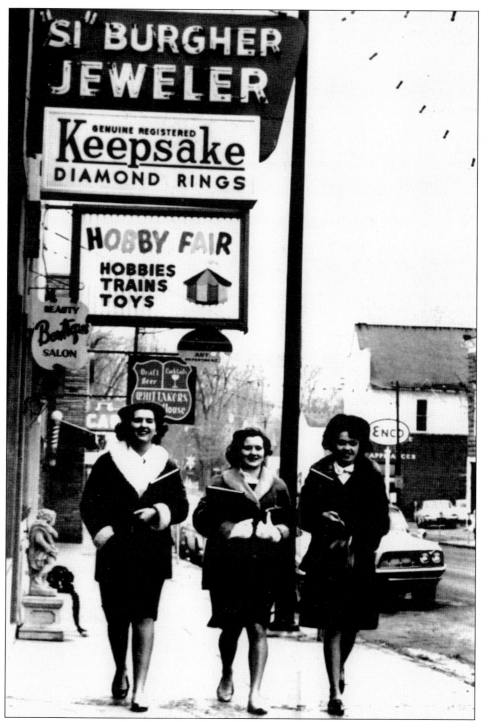

The view along West Main Street in 1964 showed many businesses thriving in downtown Carmel. The downtown area has had highs and lows since then. The current renovation effort, however, is designed to return the downtown section to a healthy vibrancy. (Courtesy of Carmel High School.)

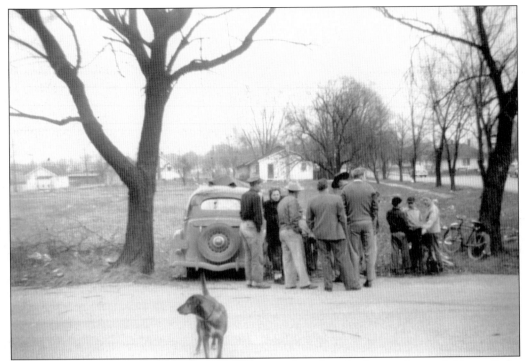

Like Carmel, the area around Home Place remained rural with plenty of open fields until the 1970s. Traffic along College Avenue usually was sparse, so when a wreck happened in 1950, like the one illustrated here, it usually drew a crowd of curious bystanders. (Courtesy of the Home Place Library and Museum.)

The first automobile wreck to warrant repair in Hamilton County, however, probably happened in 1923. Pearle "Red" Jeffries owned a 1911 Indiana-made Maxwell, which had a mishap on Hamilton County Road between Westfield and Carmel. The cancelled check shows that Carmel Garage had the honor of towing the car. (Courtesy of Phil Hinshaw.)

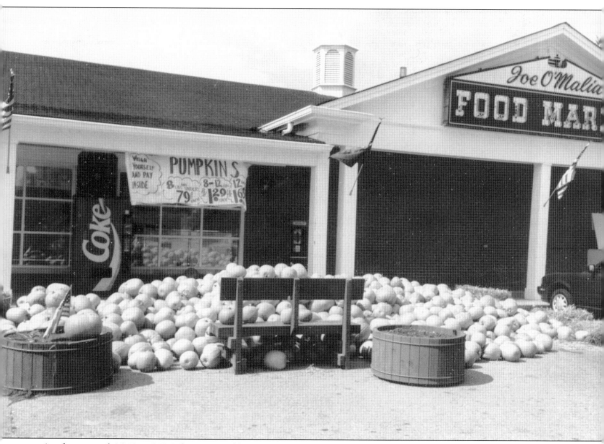

At the age of 46, Joe O'Malia opened his first grocery located at 106th Street and College Avenue in 1966. At the time, the store had installed a rare commodity in the area—an automated entrance. The store was also credited as one of the few offering a charge service that honored all the leading Midwest charge cards. O'Malia's Food Markets soon were sprouting out throughout Hamilton County and Marion County. (Courtesy of Danny O'Malia.)

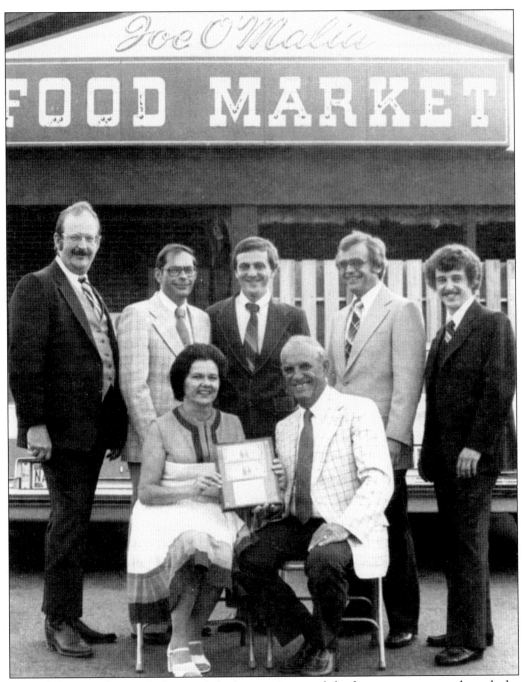

Joe O'Malia poses here with the store's former managers and the first customer to go through the check-out line, Nancy McNevin, 18 years after opening the College Avenue store. All the former managers had continued working for O'Malia in some capacity. (Courtesy of Danny O'Malia.)

Although O'Malia never intended to have more than one store, he decided that the area could use another location and opened one on Range Line Road in September 1968. Free coffee and a warm fire were added perks to a spacious, neighborly store. (Courtesy of Danny O'Malia.)

O'Malia's sixth store opened at 126th Street and Gray Road in 1982. It made headlines with the addition of Joe's Little Circus, a nursery for shoppers' children. Although the idea of in-store playrooms were popular on the East Coast at the time, such amenities were rare in Indiana. (Courtesy of Danny O'Malia.)

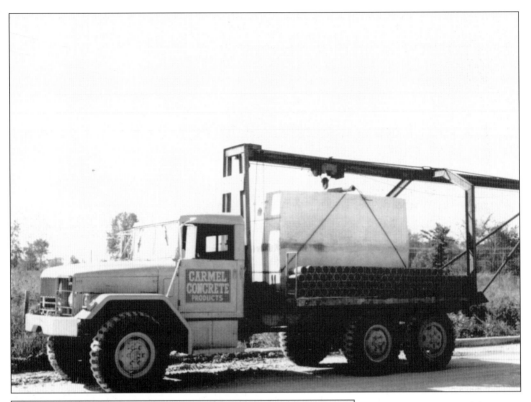

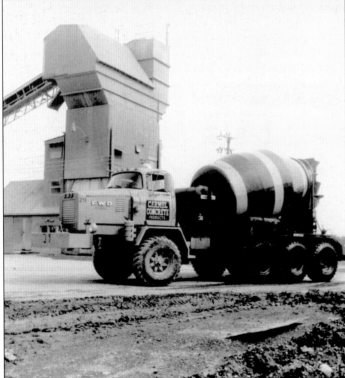

The trucks pictured here represent one of Carmel's long-standing companies, Carmel Concrete Products. Originally the company installed concrete septic tanks. When Norman Hughey purchased the business in 1950, he continued with the mainstay and made plans to expand into the ready-mix concrete business. (Courtesy of Scott Hughey.)

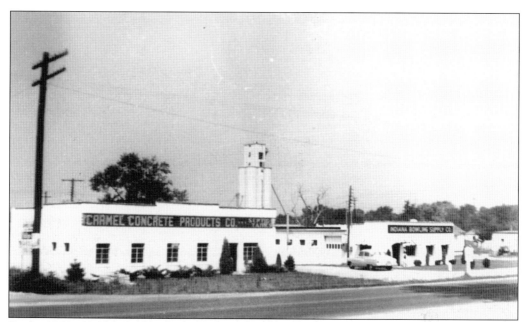

By the 1960s, Hughey had built a plant at the current site of the Colville Center. In 1972, Hughey demolished that plant and built another at Ninety-Sixth Street and Gray Road. Carmel Concrete Products now has five plants scattered throughout Indiana. (Courtesy of Scott Hughey.)

One of the highlights of Hughey's business was the job to provide all the precast concrete for one of the tallest buildings in Indiana—the American United Life Building in downtown Indianapolis. At the time, Scott Hughey (pictured in the hard hat standing at the far right) helped supervise. Today Scott leads the company. (Courtesy of Scott Hughey.)

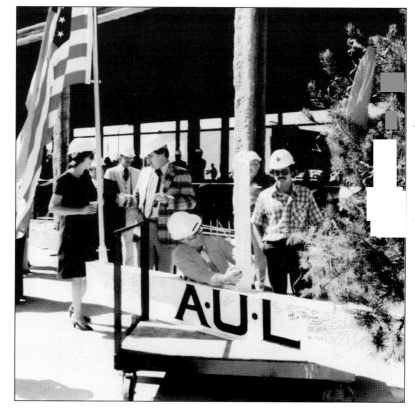

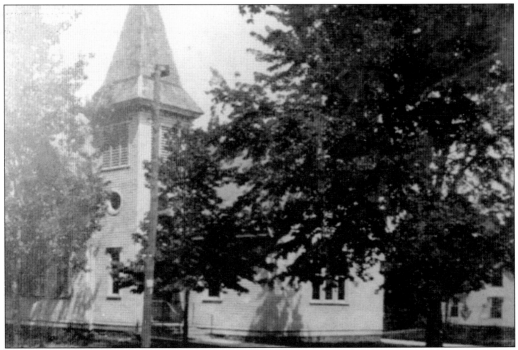

The Carmel Friends congregation built this church in 1892 on North Range Line Road. Their first meetinghouse was a log cabin, on a different site, in 1833. One of the congregation's creeds was that "an idle mind was the workshop of the Devil." They tended to include a lesson of higher learning as part of every church service. (Courtesy of the Carmel Clay Historical Society.)

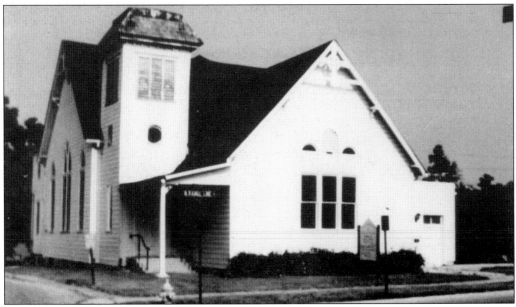

Eventually the congregation outgrew the old church and built another structure in 1962. The building was then used by the Central Christian Church. Now it is the Fellowship in Christ Church. (Courtesy of the Carmel Clay Historical Society.)

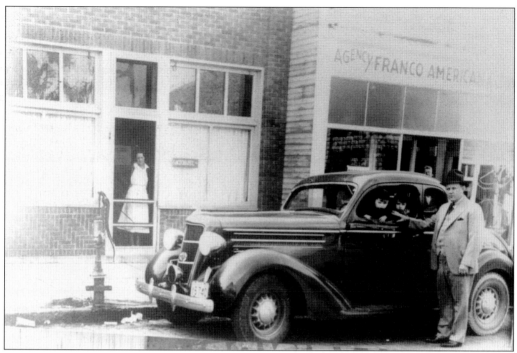

Dr. G. M. Donahue (pictured by his car) cured the aches and pains of many Carmel residents from the 1930s until his retirement in 1969. His office was part of the downtown community. (Courtesy of the Carmel Clay Historical Society.)

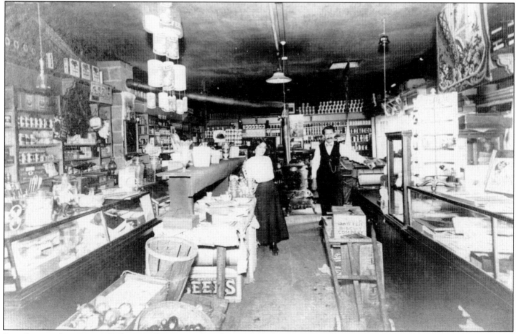

In the early part of the 20th century, downtown Carmel also was served by the Burkhardt's General Store. Sawyer's Biscuits and Old Dutch Cleanser, along with an ample supply of canned goods, were always available. (Courtesy of the Carmel Clay Historical Society.)

Harold L. Kaiser established a real estate business in Carmel in 1959 and has remained in the area ever since. Prior to opening his office, he sold real estate for about 18 years. His first office was at 30 South Range Line Road, pictured here in 1969. (Courtesy of Harold L. Kaiser.)

Kaiser Real Estate is one of the businesses in Carmel recognized for 50 years of continuous service to the community. Others include Carmel Concrete Products, Meid Compton Realty, Jeffries Billiard Parlor, Kay's Flower Shop, Kirk's Appliances and Furniture, Reeder and Kline Machine Company, and Smith Funeral Home (now Smith Carmel Chapel of Leppert Mortuary Services). (Courtesy of Harold L. Kaiser.)

About the same time that Kaiser moved the office to 30 East Main Street in 1970, he served as the first chairman of the Hamilton County Multiple Listing Association. He was also a former director of the Carmel-Clay Chamber of Commerce. Kaiser maintained his Main Street office until 1995. Today the company is part of the Coldwell Banker organization and is located near Old Meridian Street. (Courtesy of Harold L. Kaiser.)

This montage created by local artist R. Carol Skinner has combined many of Carmel's historical sites with today's street scenes from one of the first structures, Kinzer's cabin, to the city center's gazebo. (Courtesy of R. Carol Skinner)

This aerial view shows the area around Woodland Springs before the construction of the Woodland Springs Christian Church (around 1970–1971). (Courtesy of the Carmel Clay Historical Society.)

Standard Locknut, which was on South Range Line Road at the corner of Carmel Drive, was once one of the town's largest employers. The location is now used by Party Time Rentals. (Courtesy of the Carmel Clay Historical Society.)

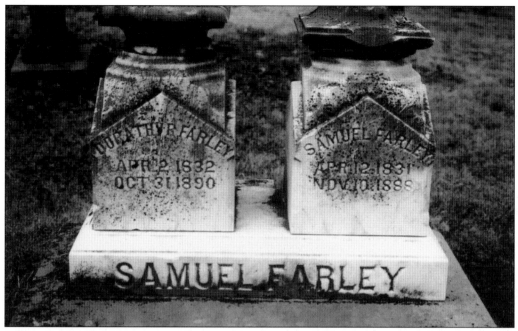

When the Brookshire area was developed in the early 1970s, remains of early pioneers were moved to Farley Cemetery. This is one of the area's earliest cemeteries and is located on the southeast corner of 106th Street and Keystone Avenue. (Courtesy of Terri Horvath.)

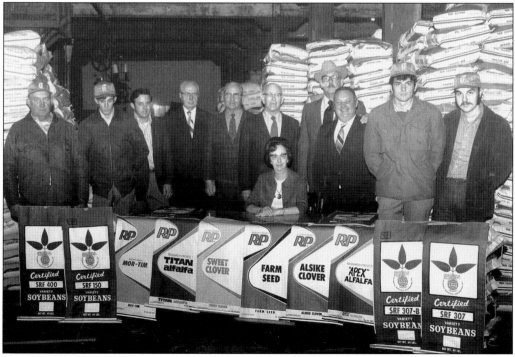

In 1972, employees at Foster and Kendall included Russell Helms, Jesse Killman, Ernest Antte, John Roach, Charles Scott, Irene Eaglin, Jesse Taggart, Bud Chinski, Gene Thompson, and Dave Clark. (Courtesy of the Carmel Clay Historical Society.)

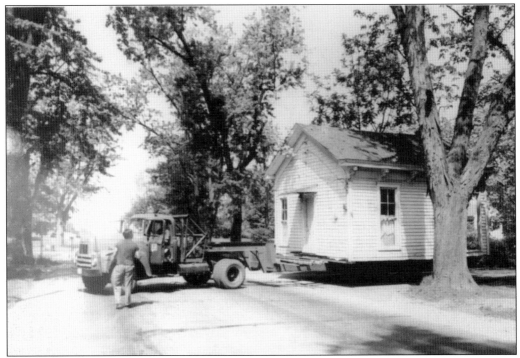

In 1976, a wing of a large home once owned by Zina Warren at 250 West Main Street was moved to 30 West Main Street. Known as the Bicentennial House, it was built about 1875. Phil Hinshaw, a Carmel businessman and long-time resident, donated the 16-by-20-foot structure. Its last occupant was his father, Rue Hinshaw, a town board president. (Courtesy of the Carmel Clay Historical Society.)

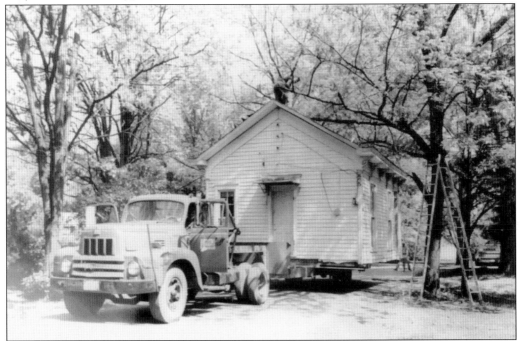

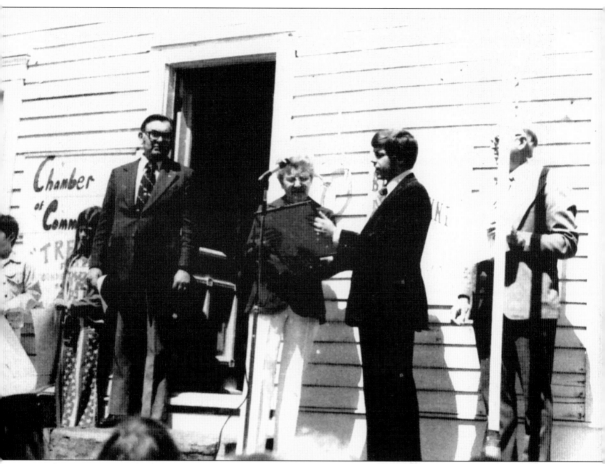

The Bicentennial House became the office of the Carmel-Clay chamber. Restoration work was completed by Harlan and Pearl Tudor. Pictured above is the dedication ceremony. In 1993, the house became the Carmel Arts Council House, recognized by the Guinness Book of World Records in 1999 as being the world's smallest children's art gallery. (Courtesy of the Carmel Clay Historical Society.)

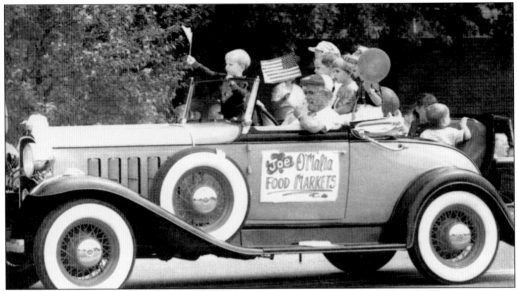

For decades, Carmel hosted an Independence Day parade along its main streets. One annual parade tradition for several years was the appearance of the green 1932 Oldsmobile belonging to Joe O'Malia. As homage to his proud Irish heritage, the company added a shamrock and a leprechaun named Dennie to its logo in 1981. (Courtesy of Danny O'Malia.)

Another parade favorite was the annual appearance of horses, a tradition dating back to the Carmel Horse Show. Add that attraction to the veiled belly dancers in 1979, and the parade had another hit. (Courtesy of Mike Wannemacher.)

Four

AT SCHOOL

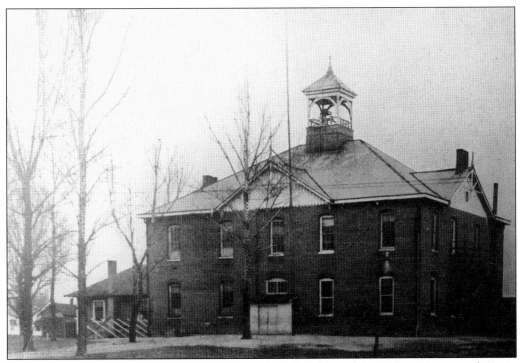

Carmel's school system started in a one-room log church on the northeast corner of Range Line Road and Smokey Row Road in late 1833 or early 1834. By 1887, the town had built the first Carmel High School located with the boundaries of First Avenue Southeast on east, Sixth Street Southeast on the south, and Range Line Road on the west. The building pictured above was known as the Blue School for unknown reasons. (Courtesy of the Carmel Clay Historical Society.)

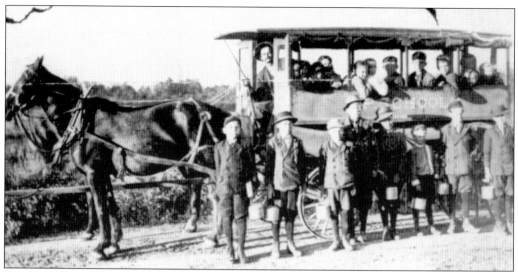

Between 1890 and 1922, Carmel graduated 382 students, an average of about 14 per year. Pictured here are some of the younger students in the early 1900s. The Carmel school accommodated students throughout Clay Township. (Courtesy of Phil Hinshaw.)

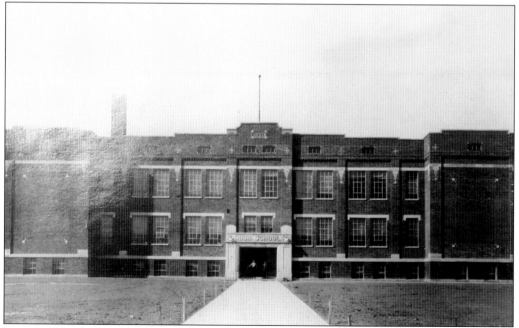

In 1921, the Blue School was abandoned, and a new school for students in all grades was built at the corner of East Main Street and Fourth Avenue Northeast. Eventually other schools were built, and this building accommodated only high school students. (Courtesy of the Carmel Clay Historical Society.)

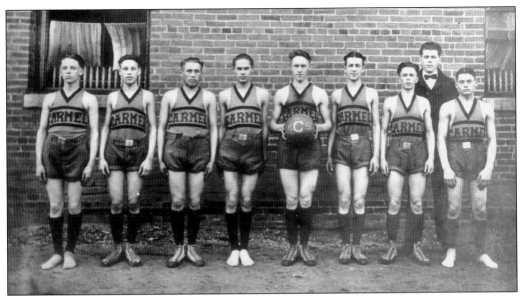

One of the last photographs taken with the 1887 school as a backdrop was this one, which features the basketball team (around 1920). Members included, from left to right, Johnny Moffitt, Errol Myers, Albert Riggles, Everett Johnson, Clarence Carson, William Rayle, Kenneth Smith, coach Emile Kenyon, and Ralph Applegate. (Courtesy of the Carmel Clay Historical Society.)

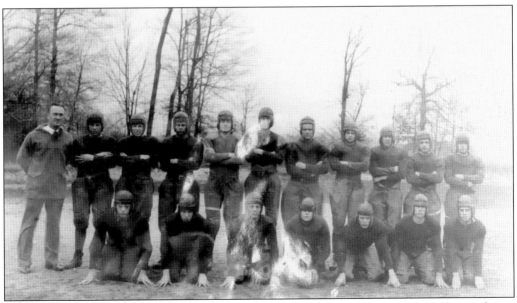

The 1929 football team represented a town of about 680 residents. Previous census figures show a population of 498 in 1900 and 598 in 1920. (Courtesy of the Carmel Clay Historical Society.)

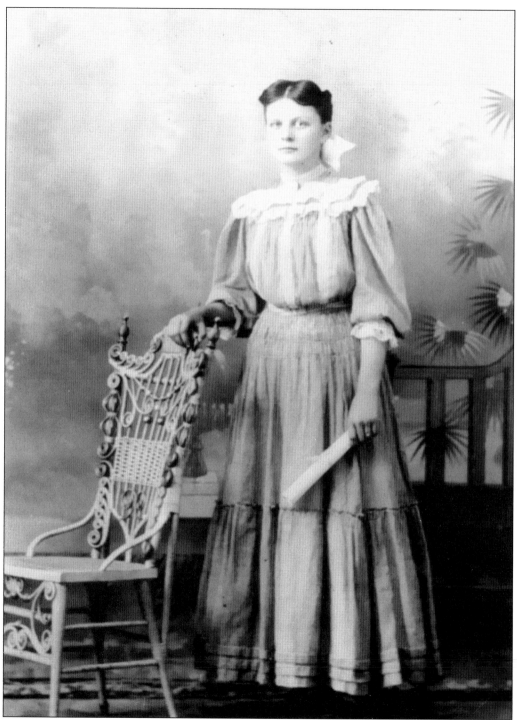

The graduation photograph of Olive Brown Brunner was taken in 1928. After obtaining her teaching credentials, Brunner returned to Carmel High School as a teacher and remained there for about 50 years. (Courtesy of the Carmel Clay Historical Society.)

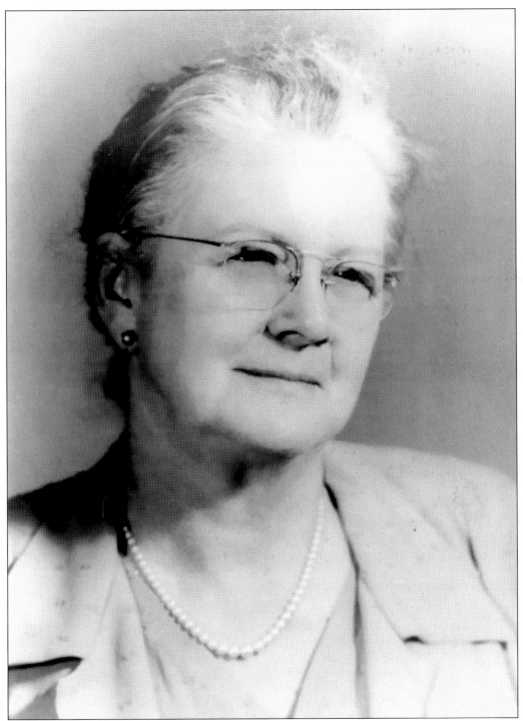

Brunner is credited for starting the first bookstore, which she operated from the trunk of her car, and the first cafeteria, using her home economics class. Her efforts were part of a school system that graduated 15,532 students between 1959 and 1993. (Courtesy of the Carmel Clay Historical Society.)

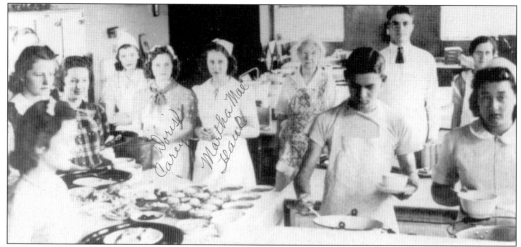

The school's lunch crowd filtered through the home economics department in the 1940s and 1950s. About 100 to 150 elementary and high school students patronized the school's cafeteria. Helping to serve the food were students in the home economics department. (Courtesy of Carmel High School.)

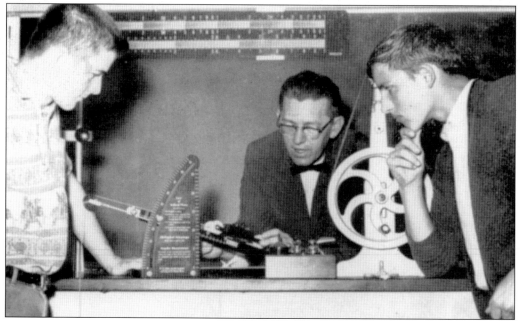

Many Carmel High School students passed through the science classes of Mr. Coombs. Pictured here in the 1960s, Mr. Coombs (center) is explaining the theory of an inclined plane to students Paul Hannah (left) and Bob Hendren (right). (Courtesy of Carmel High School.)

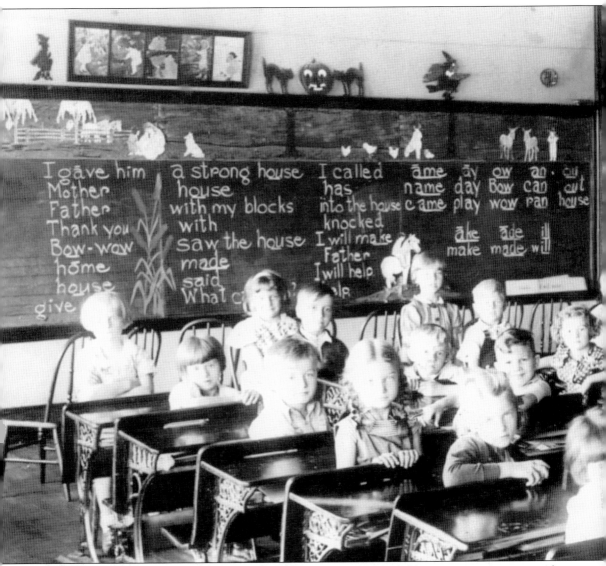

Pictured above is the first grade class of Carmel in about 1936. Children in various sections of Clay Township came to the Carmel school. Eventually many other elementary buildings were constructed throughout the township to accommodate the growing population. (Courtesy of the Home Place Library and Museum.)

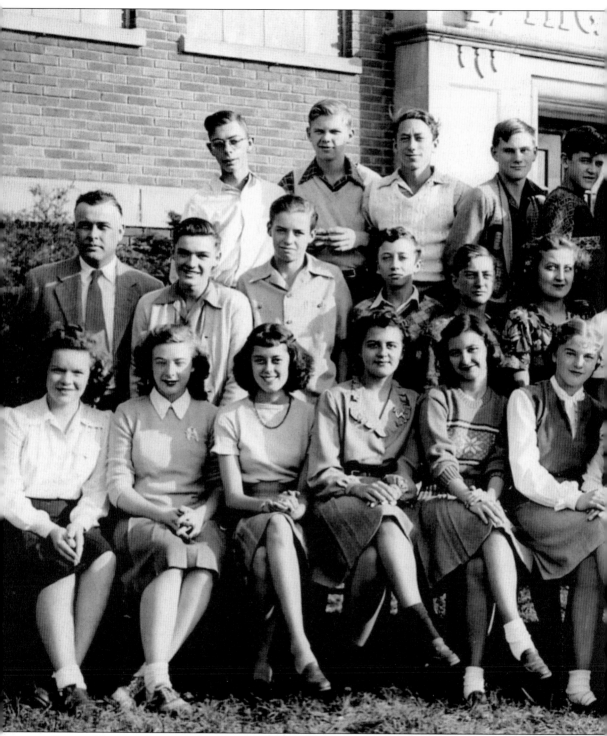

Pictured here is the Carmel High School class of 1948. One of its graduates was Marvin Pike (second from the left, third row), a long-time area resident of Home Place. Today Pike is recognized on the school's Wall of Fame as a survivor of the Battle of Chosin Reservoir in Korea,

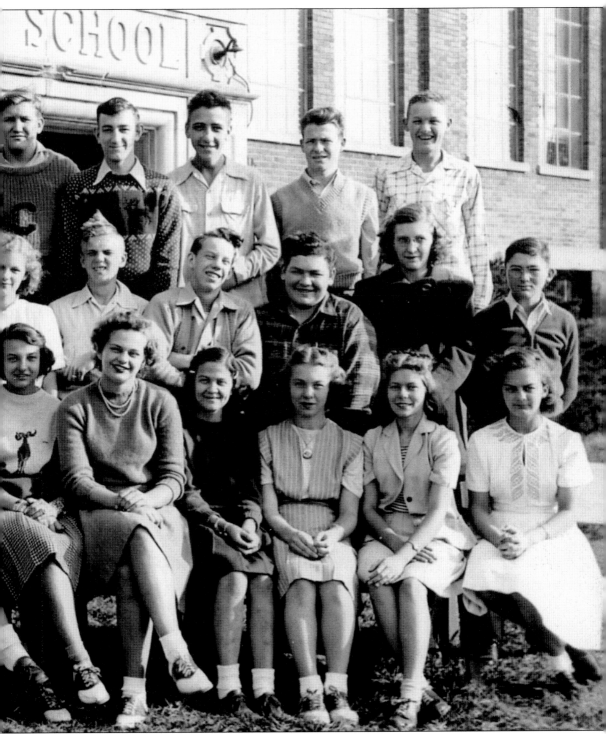

and as the first official manager of the Clay Township Region Waste District. He also helped form and manage the Home Place Library and Museum. (Courtesy of the Home Place Library and Museum.)

In 1936, at the height of the Great Depression, football was abolished at Carmel High School. The sport did not return until 1951. During its regular season in 1952, the Greyhounds won the opening game against the team from Sheridan High School. Coaches Waverly Myers (pictured left) and Dick Lamb led the team to four wins, one tie, and two losses for the season. (Courtesy of Carmel High School.)

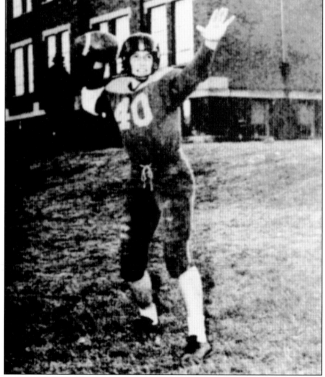

Eric Clark led the 1952 team as its quarterback. He came back to Carmel High School as a teacher and a basketball coach. In fact, he was the coach of the locally renowned 1977 team that won the school's first state basketball championship. (Courtesy of Carmel High School.)

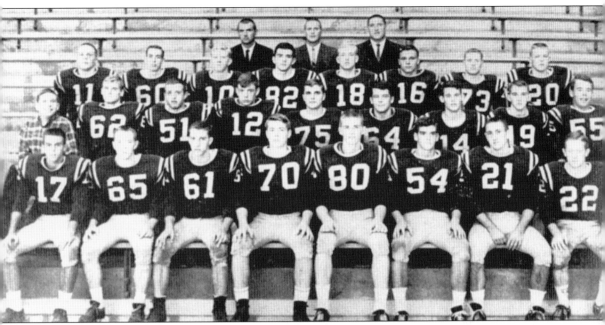

Former Baltimore Colts player Dick Nyers came to Carmel to coach football from 1958 to 1968. He led his teams to two undefeated seasons in 1964 and 1965. He is pictured in the fourth row between the other coaches (left to right) B. Johnson and E. Clark. (Courtesy of Carmel High School.)

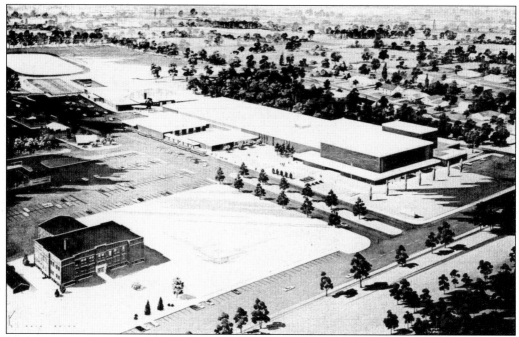

A new high school was erected in 1958. The school planner allotted enough space for additions, which came in 1963, 1969, and 1977. The illustration from a 1970 dedication program for a new addition shows the 1921 building next to the current one. The president of the Board of Education in 1970 was Richard Helmut, superintendent of schools was Dr. Robert Hartman, and the principal was Dale E. Graham. (Courtesy of the Carmel Clay Historical Society.)

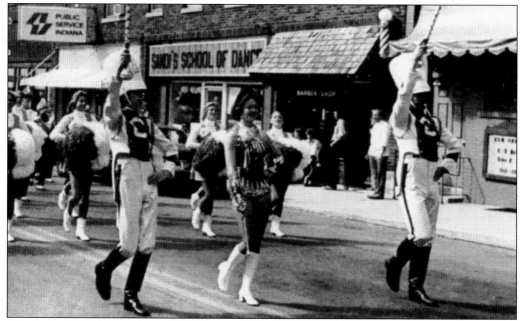

The high school band is another source of pride for Carmel. Shown here in the 1950s, the band has continually grown and improved. In recent years, the band has had impressive showings in state band competitions. (Courtesy of the Carmel High School.)

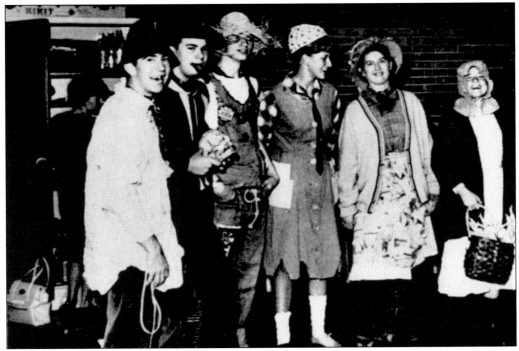

One tradition during the 1960s was the annual Slop Day. Seniors were given the opportunity to show their versions of sloppy at least one day every year. Seniors in 1964 choosing an alternative means of expression are (from left to right) Chuck Somes, Joe Burks, Norm Houck, Nancy White, Elyce Pfotenhauer, and Leslie Dawson. (Courtesy of Carmel High School.)

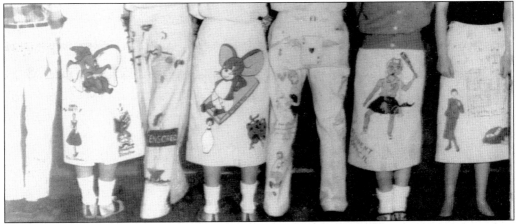

Another fad during the 1960s and 1970s was the "senior cords." Each wearer of a corduroy skirt or corduroy slacks had the apparel decorated with emblems representing his or her interests. Apparently, Walt Disney cartoon characters were popular in the sixties. (Courtesy of Carmel Clay High School.)

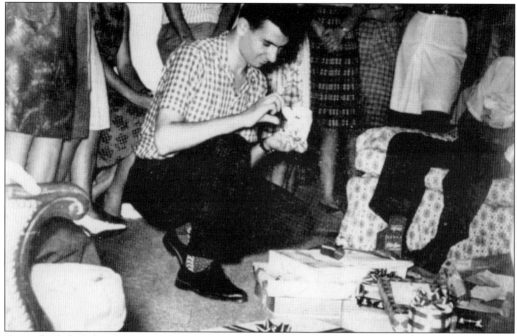

Carmel High School's first foreign exchange student arrived in 1964. At the age of 19, Mesut Ozdeniz traveled from Trabzon, Turkey, to Carmel for the school year. Here he is photographed at a welcoming party hosted by the Hinshaw family. (Courtesy of Carmel High School.)

One noted and accomplished 1967 graduate of Carmel High School is William Silvers, M.D. He obtained his medical degree from Indiana University in 1974 and went on to establish acclaim in the field of allergy and immunology. He currently practices in Englewood, Colorado, and is noted for his work as medical director for Asthma Ski Day, an event he developed for children with asthma to help them cope with participating fully in cold weather. (Courtesy of Carmel High School.)

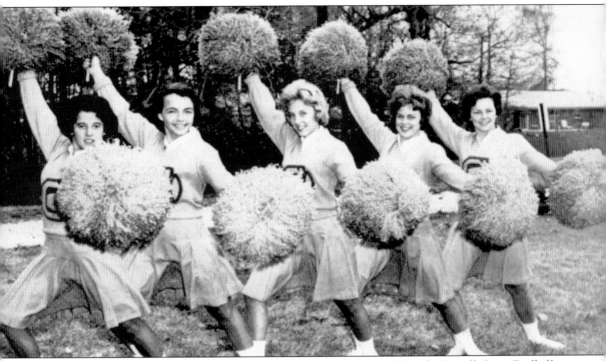

Varsity cheerleaders for the 1964 school year were (from left to right) Jody Correll, Susie Radloff, Sally McCracken, Sally Durfee, and Judy Hinshaw. In addition to rooting for the home teams, these cheerleaders were responsible for planning many of the year's pep rallies. (Courtesy of Carmel High School.)

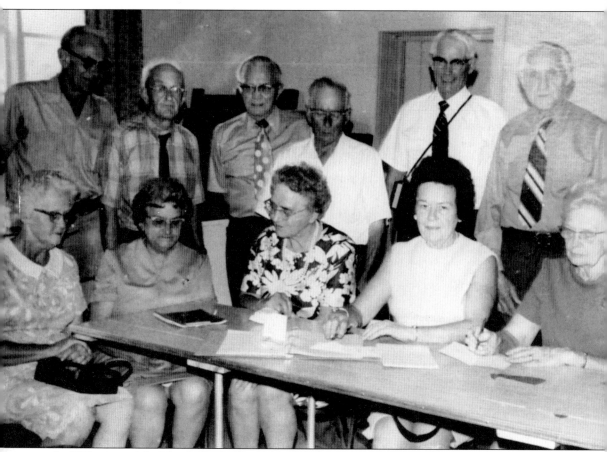

In 1971, some of the Blue School's alumni attended a reunion held at White Chapel Church. Seen here are, from left to right, (first row) Ruby Williamson, Beatrice Stoner, Bernice Mohler, Sylvia Dale, and Chirta Corbin; (second row) Sam Pursel, Aley Hunt, Dagle Corbin, Howard Williamson, Frank Pursel, and Clarence Carson. (Courtesy of the Carmel Clay Historical Society.)

With only four seconds left in the game, Jon Ogle of the Carmel Greyhounds made the shot that gave the basketball team its first state championship in basketball in 1977. The high school press indicated that "this game ranks right up there with Milan's shocker in 1954 and Connersville upset win over Gary West in 1972." The underdog, Carmel High School, won over East Chicago Washington. Since then, several Carmel High School athletic teams have gained state championships. The players pictured here are shown during the award presentation after the big game. (Courtesy of Carmel High School.)

Mark Hermann, the class of 1977, helped lead the basketball team to its first state championship in 1977. He also gathered local acclaim during his high school days as the football team's quarterback. (Courtesy of Carmel High School.)

During Hermann's college career at Purdue University, he was named All-American. He went on to play a few seasons as a professional in the National Football League, including a stint with the Indianapolis Colts. (Courtesy of the Indiana Basketball Hall of Fame.)

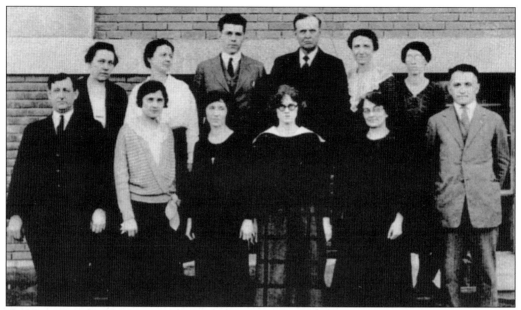

As the student population increased, so did the number of Carmel High School teachers. In 1921, the faculty included, from left to right, (first row) Principal Earl Hinshaw, Mary Klingensmith, Bertha Leitz, Susie Stewart, Christina Williamson, John Caylor; (second row) Edna Warren, Olive Brunner, Emil Kenyon, Mr. Kenyon, Mrs. Commons, and Mable Myers. (Courtesy of Phil Hinshaw.)

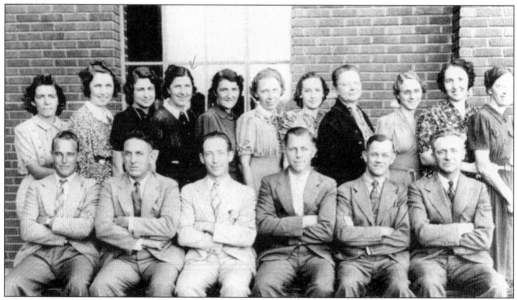

By 1942, the faculty size increased by five. They included, from left to right, (first row) Walter Mosbaugh, Edgar Cotton, Bill Fish, Estell Hiatt, Chester Quear, and Russell Fisher; (second row) Charlotte Pierce-Smith, Elsie George, Mozelle Chance, Imo H. Newby, Martha Gilbert, Alma Musselman, Marion Noggle, Olive Brunner, Kathleen Flannigan, Mildred Newlin, and Mable Myers. (Courtesy of Phil Hinshaw.)

Five

NEIGHBORS

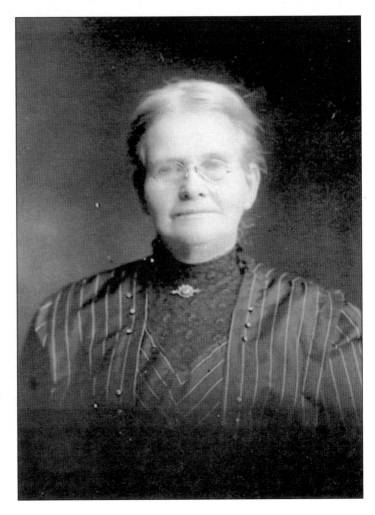

One long-time neighbor to the Kinzers, the Moons, and other Carmel residents was Angelina Warren Gray Jackson, born in 1832. She died in 1925. One of her great-grandchildren was long-time area resident Donald R. Morrow. (Courtesy of the Carmel Clay Historical Society.)

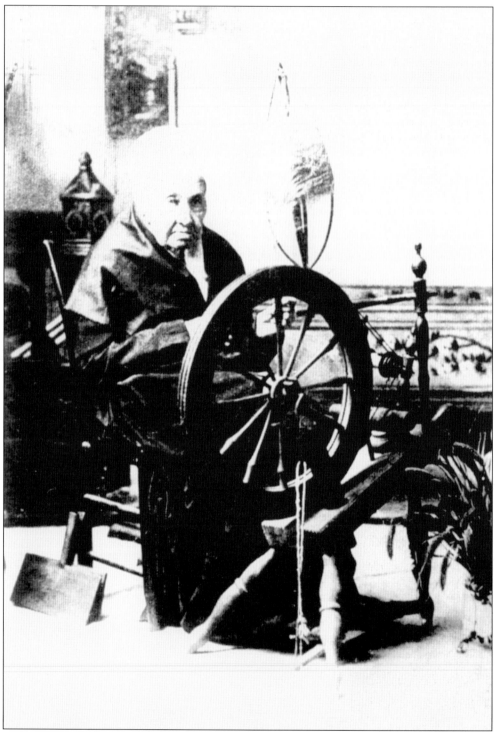

Another early resident of the area was Alethea Coffin, shown here in later years. She was born April 16, 1798. She lived to be 93 years old and died on November 4, 1891. (Courtesy of Phil Hinshaw.)

On June 9, 1900, William Frank Carey was the first Carmel police officer killed in the line of duty. Carey was deputized to assist in the arrest of Thomas Jefferson Johnson, also known as "Cyclone Johnson." Johnson was also shot and killed. (Courtesy of the Carmel Clay Historical Society.)

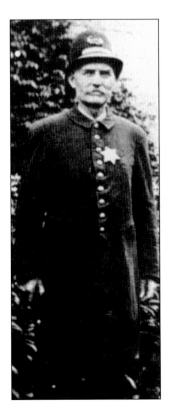

By 1906, a segment of law enforcement was the Merchants Police. Pictured in uniform is Edward Evans, who was 65 years of age at the time. (Courtesy of Phil Hinshaw.)

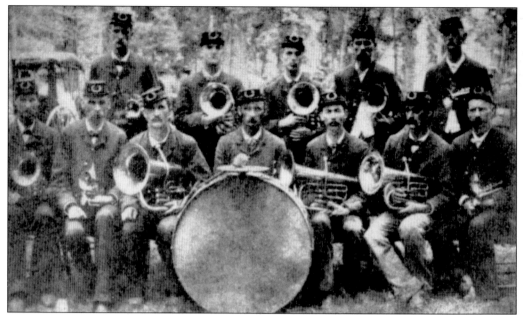

Pictured in 1884, this band was known as both the Carmel Band and the Haines Band. Most of the members belonged to the Haines family. Pictured here are, from left to right, (first row) Will Brunson, J. F. R. Haines, Albert Haines, Oliver Haines, Will Kinzer, Elwood Haines, and John Haines; (second row) Ira Haines, Luther Haines, Will Warren, Eli Binford, and Frank Haines. (Courtesy of Phil Hinshaw.)

Frank Williamson was born in 1845 about three and a half miles southeast of Carmel and attended the Blue School. He earned a teaching degree and taught in Castleton, Broad Ripple, and Carmel. Upon his retirement, he returned to his Carmel farm, where he died at age 95. (Courtesy of Phil Hinshaw.)

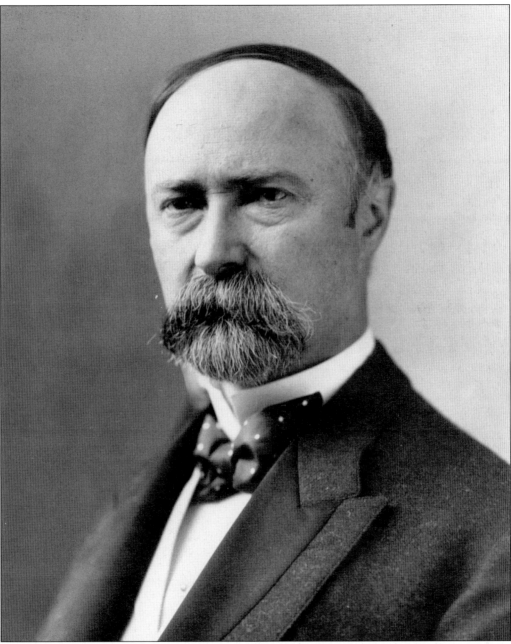

One of Carmel's most esteemed residents was Charles W. Fairbanks, vice president of the United States from 1905 to 1909, serving with Pres. Theodore Roosevelt. Although Fairbanks tried to secure the Republican presidential nomination in 1908, the nod went to William Howard Taft. He returned to Indiana to live the life of a country gentleman and was marginally active in state politics. (Courtesy of the United States Senate Historical Office.)

Carmel resident Franklin Booth was a national known artist during the 1920s–1940s. He illustrated books by such famous authors as Theodore Dreiser, Meredith Nicholson, and James Whitcomb Riley, who were all Hoosiers as well. In fact, Riley was a frequent visitor to the Booth home. (Courtesy of the Carmel Clay Historical Society.)

Booth's highly detailed pen and ink drawings were used by many major magazines of the day. A sample of his work is shown to the right in a personal letter in which he writes "All these things and the many other events of the life around Gray [Road], as time goes on, become almost the main things in a man's life, and they stick in my memory more than all the things else." Booth is also pictured below in his studio. (Courtesy of the Carmel Clay Historical Society.)

All these thing
events of the l
time goes on, b
things in a man
stick in my mem
things else. A
a bird. It buil
places of his b
or how far afie
tion it returns
to bring forth
joy. This is th
ness the poets

Even now there
the time we ble
the little hay
the young woods
dynamite to cau
come out of his
surprised-like
to make a sound
tied the mare
spun her around
she should have
place.

But I am not f
things, the in
agement I got
go ahead and d
have done. Nor
letter of over
come to when c
from my own ho
how beautiful
so in the fell

Bee and I rene
hope you both
that ripe age
grandfather al
drem.

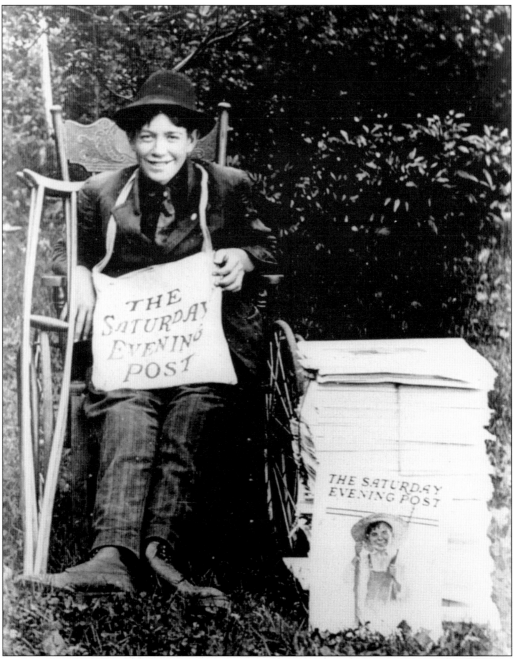

Franklin Booth often employed Carmel residents as models for his drawings—possibly this young man who was often seen in Booth's company. In later years, this young man became Booth's driver. For many years Booth lived in a frame, Italianate-style home at 321 North Range Line Road. (Courtesy of the Carmel Clay Historical Society.)

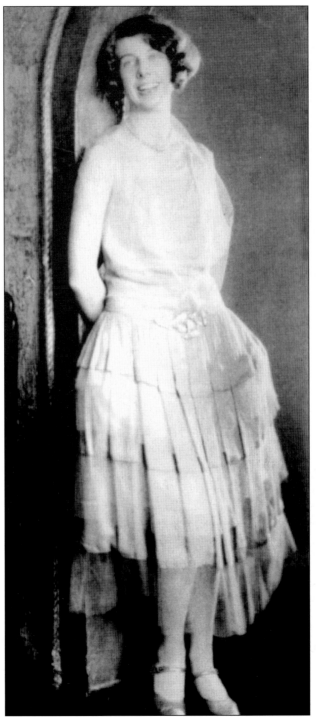

A locally known actress was Dorothy Haines, pictured here around the late 1920s or early 1930s. She performed in plays, even touring throughout the country and the British Isles. She also taught dramatics for three years at the Metropolitan School of Music in Indianapolis. (Courtesy of Phil Hinshaw.)

One long-time resident of Clay Township was Mabel Howard, pictured here in her Home Place house around the mid-1950s. The strict boundaries of the platted areas extended from about 109th Street on the north to 104th Street on the south and from McPherson Street on the east to College Avenue on the west. (Courtesy of the Home Place Historical Library and Museum.)

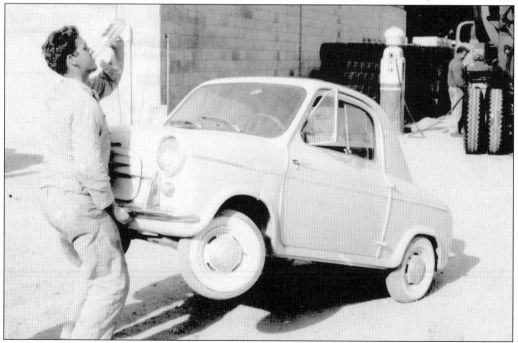

One employee at Carmel Concrete Products shows his sense of humor during a break. He was among those who helped in the growth of the company from one owning less than six trucks to one with 43 ready-mix trucks and 85 employees. (Courtesy of Scott Hughey.)

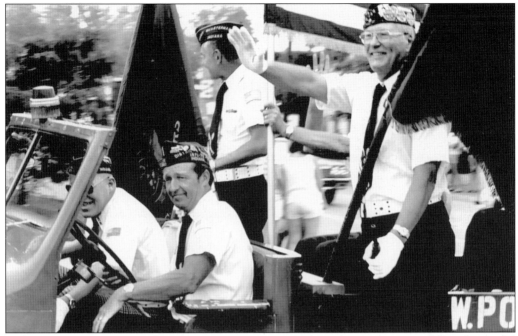

Military service, represented by these veterans in a 1980s parade, was a responsibility that many Carmel residents followed. For example, 120 local men enlisted during World War I. Only one was killed. In World War II, eight were fatally injured. (Courtesy of Mike Wannemacher.)

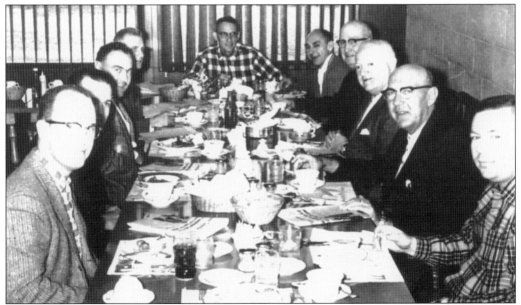

The Carmel-Clay Chamber of Commerce's first meeting was held at Charley's Steakhouse in 1962. Seated are, clockwise from bottom left, Dr. David E. Laycock, Dr. Ron Turner, Thomas D. Wilson, Forrest M. Stoops, John Klingensmith, Max Colville, R. Wyatt Carey, Virgil V. Thornberry, Sherman D. Wilson, and Tom Quellhorst. The organization lasted only a short time. It was revitalized in 1970 and has continued a strong presence since then. (Courtesy of the Carmel Clay Historical Society.)

A friend living in Hollywood introduced John Kirk, owner of the long-time Carmel business John Kirk Furniture, to many Hollywood stars and celebrities. Some have stopped by occasionally for a visit, such as Col. Harland David Sanders of Kentucky Fried Chicken, in 1975. Pictured with Colonel Sanders are, from left to right, Kirk family members John, Edith, Bob, Linda, Tom, and Kenny. (Courtesy of Tom Kirk.)

On December 20, 1975, Indiana Gov. Otis Bowen (right) swore in the first Carmel City Council. Pictured are (from left to right) Dr. Walter Dean, Minnie Doane, James Garretson, Stan Meacham, and Jane Reiman, who later became mayor. David Coots and Fred Swift (not pictured) were also council members. (Courtesy of the Carmel Clay Historical Society.)

Edith Hobbs, a long-time resident who served in many civic roles, was honored at the 1987 Founders Day event with a certificate given by Sen. Richard Lugar. Her family, the Applegates, was among the first to settle in the area. Hobbs lived to be about 100 years of age. (Courtesy of the Carmel Clay Historical Society.)

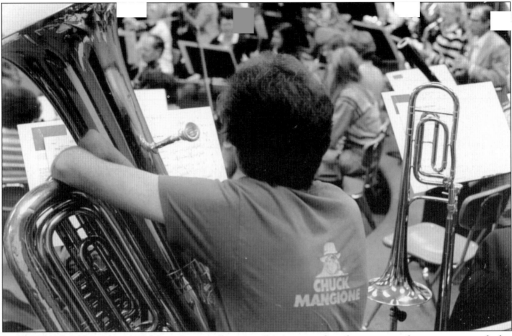

In 1976, 15 volunteers, who came together to play music for their own pleasure, started the Carmel Symphony Orchestra. One of the early members was Ann Manship, who eventually became concertmistress in the early 1980s. (Courtesy of Terri Horvath.)

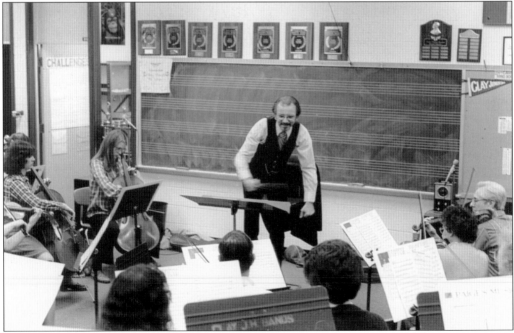

By 1996, the group had grown into a thriving 65-member orchestra performing with such guest artists as jazz pianist Peter Nero and the Ramsey Lewis Jazz Quartet. Another highlight is the Carmel Symphony Orchestra's series of programs designed for children. (Courtesy of Terri Horvath.)

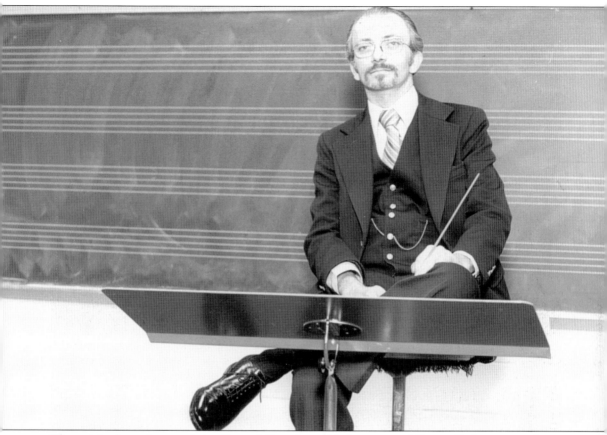

The original conductor of the Carmel Symphony Orchestra was Viktors Ziedonis, a violinist with the Indianapolis Symphony Orchestra for 18 years. He led the orchestra during its first two seasons. James Edington (pictured above in 1981) took over for the next three seasons, while he continued to teach music lessons. (Courtesy of Terri Horvath.)

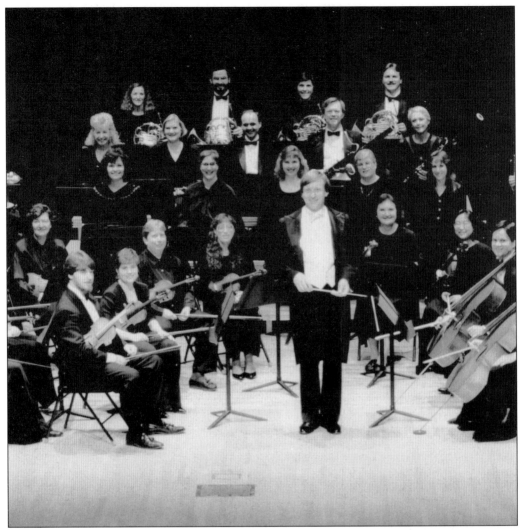

Once serving as a guest conductor, David Pickett took the baton full-time in 1984. One of his achievements was the formation of the Carmel Symphony Orchestra Chorus, which has performed in both the Liverpool Oratorio and the Robert McFarland concerts. The current music director and conductor is David Bowden. (Courtesy of the Carmel Symphony Orchestra.)

Since Carmel Symphony Orchestra's earliest beginnings, two guest vocalists have returned repeatedly to perform with the orchestra—Ken Knowles and Ann Conrad. Both work as teachers at the Carmel High School. Knowles has taught English for nearly 34 years at Carmel High School. Conrad has served nearly that long as one of the choral music directors. They have performed together for about 25 years. (Courtesy of the Carmel Symphony Orchestra.)

The Carmel Jaycees was organized here in 1959. The nationally affiliated group focused on providing leadership training for young men through community service and social activities. The group disbanded primarily because of competition from many other service and community groups in the area. Pictured here is Phil Manship in 1979. (Courtesy of Mike Wannemacher.)

Like the Jaycees, there have been many civic-oriented groups serving the Carmel community. One of those was the American Legion Junior Auxiliary, pictured here in 1938. (Courtesy of Phil Hinshaw.)

In 1971, the Carmel Jaycees perceived the need for fireworks to celebrate the Fourth of July. Residents gathered for many years for the Jaycees display, lit by the group's own members. Pictured (around 1980) are, from left to right, Jaycee members Dave Adams, Mark Simonetto, and Phil Manship. (Courtesy of Mike Wannemacher.)

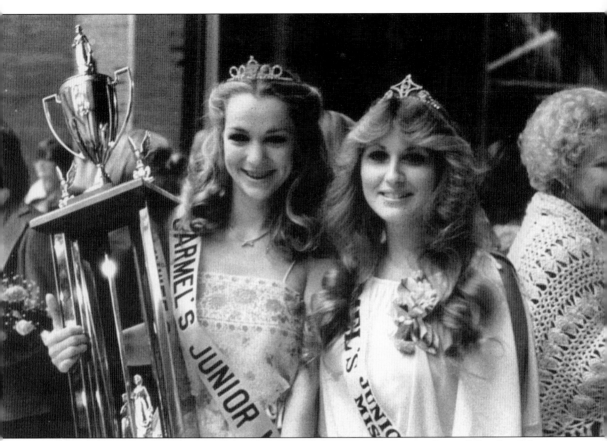

One of the activities sponsored by the Carmel Jaycees was sponsorship of the local Junior Miss pageant from the early 1960s until 1982. It was part of America's Junior Miss, a national scholarship program for high school seniors. Pictured here are two past winners from Carmel, pictured in 1979. (Courtesy of Mike Wannemacher.)

The Reverend Dr. Warren Saunders moved to Carmel in 1964, when he became pastor of the Carmel United Methodist Church. Reverend Saunders served this congregation for 18 years until his retirement. Afterward he remained in Carmel and continued serving the community on various boards and in many civic clubs. His resume included work with the Carmel Symphony Orchestra Board, president of the Hamilton County Democratic Club, the Hamilton County Convention and Visitors Commission, president of the Carmel Lions Club, and the Carmel-Clay Chamber of Commerce. (Courtesy of the Carmel Symphony Orchestra.)

In 1980, Jane Reiman became Carmel's first female mayor and served two terms. During her first term, Carmel changed its status from town to city. She is pictured here in 1982 at a Joe O'Malia Food Market store opening with, from left to right, Grover Parido, Danny O'Malia, and Joe O'Malia. (Courtesy of Joe O'Malia.)

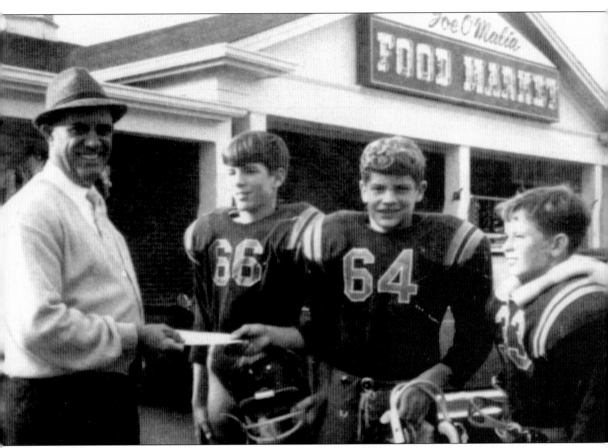

Like many of the local businesses in Carmel, Joe O'Malia Food Market was a strong community supporter. The photograph above shows Joe O'Malia presenting a check to underwrite equipment needs for the Carmel Pups football team in 1970. (Courtesy of Danny O'Malia.)

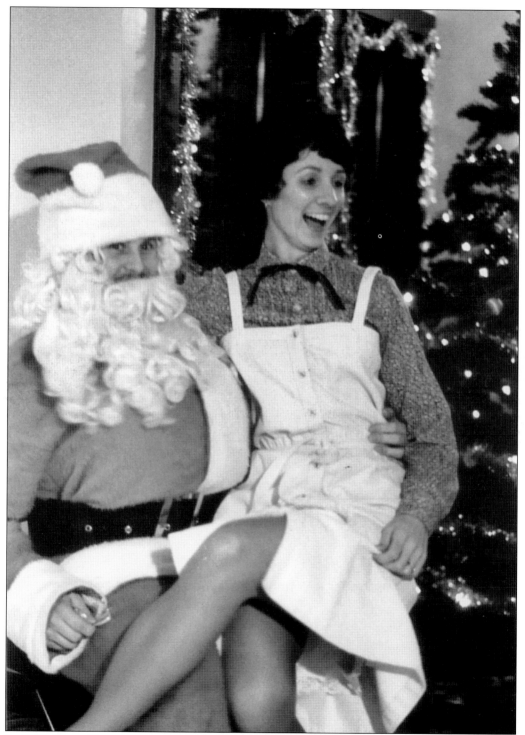

In 1980, Santa Claus came to the former Target Plaza at the corner of 116th Street and Keystone Avenue. Bill Davis donned the Santa suit with Kathy Hockett serving as his merry helper. (Courtesy of Mike Wannemacher.)

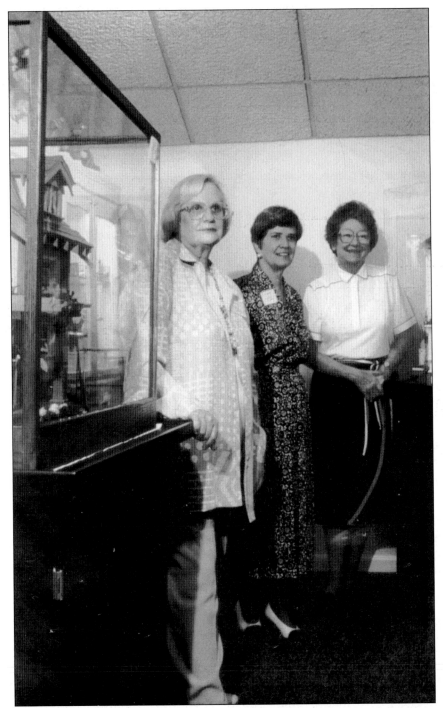

The Museum of Miniature Houses and Other Collections may be tiny, but it has a major presence in the world of miniature enthusiasts. People from around the country come to Carmel just to take a look inside this converted house on Main Street. The museum was started by three long-time residents, (from left to right) Suzie Moffett, Suzanne Landshof, and Nancy Lesh, in 1991. (Courtesy of The Museum of Miniature Houses and Other Collections.)

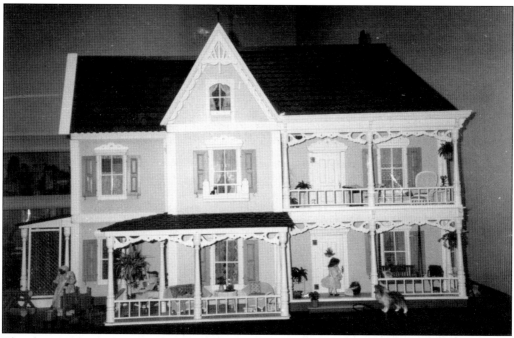

The three museum founders had a passion for building their miniature houses and wanted to share their own and others' works with the public. Here is a miniature house built by Landsof representing one found during 1881. The project took her five years to complete. (Courtesy of The Museum of Miniature Houses and Other Collections.)

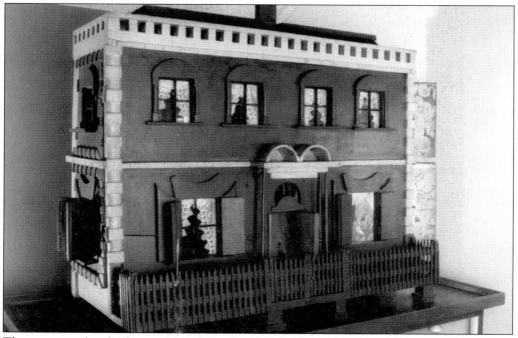

The museum also displays antiques like this 1861 house on loan from a Greenwood resident, which was handed down from her mother. The house's details include original wallpaper from the house it represents. (Courtesy of The Museum of Miniature Houses and Other Collections.)

R. Carol Skinner became a Carmel resident in 1971, about five years after graduating from John Herron Art School. She has combined her interest in art and history by sketching some of the area's historical homes and landmarks. (Courtesy of R. Carol Skinner.)

The first Methodist church built in Carmel was one of Skinner's first art works after moving to Carmel. She has created an elegance in the now-abandoned relic. (Courtesy of R. Carol Skinner.)

One of Skinner's works is this 1975 representation of the old store building built in 1874 near the corner of East 116th Street and Haverstick Street. The surrounding area was known as Mattsville, which was a stopover for the stage line. The church's construction began in 1850. (Courtesy of R. Carol Skinner.)

Another example is the 1976 drawing of the McShane House built in 1886 on Westfield Boulevard. Arriving in the area in 1825, Francis McShane was the first white settler in Clay Township. James Gray McShane built the house in 1886 on Francis's original homestead. (Courtesy of R. Carol Skinner.)

ACROSS AMERICA, PEOPLE ARE DISCOVERING SOMETHING WONDERFUL. *THEIR HERITAGE.*

Arcadia Publishing is the leading local history publisher in the United States. With more than 3,000 titles in print and hundreds of new titles released every year, Arcadia has extensive specialized experience chronicling the history of communities and celebrating America's hidden stories, bringing to life the people, places, and events from the past. To discover the history of other communities across the nation, please visit:

www.arcadiapublishing.com

Customized search tools allow you to find regional history books about the town where you grew up, the cities where your friends and family live, the town where your parents met, or even that retirement spot you've been dreaming about.